OCT 1999 02/01 1 3/00
1/04 2 3/01

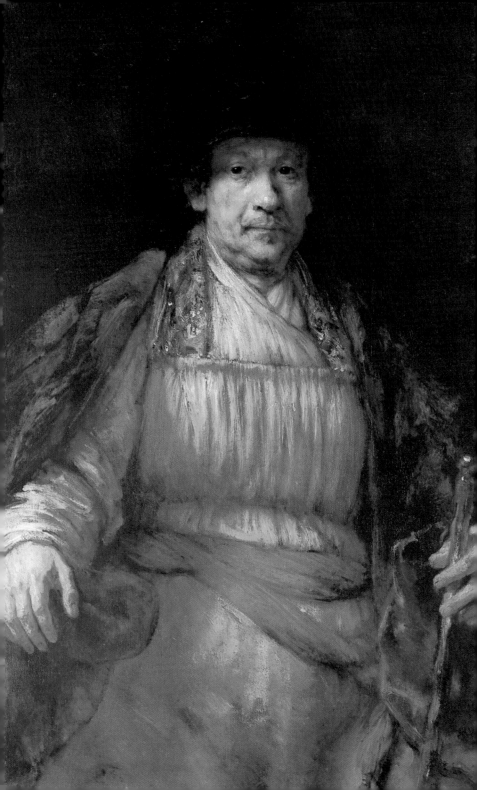

ArtBook
Rembrandt

DORLING KINDERSLEY

London • New York • Sydney • Moscow

Visit us on the World Wide Web at http://www.dk.com

Contents

1606–1627

1627–1632

How to use this book

This series presents both the life and works of each artist within the cultural, social, and political context of their time. To make the books easy to consult, they are divided into three areas, which are identifiable by side bands: yellow for the pages devoted to the life and works of the artist, light blue for the historical and cultural background, and pink for the analysis of major works. Each spread focuses on a specific theme, with an introductory text and several annotated illustrations. The index section is also illustrated and gives background information on key figures and the location of the artist's works.

■ Page 2: Rembrandt, *Self-portrait* (detail), 1658, Frick Collection, New York.

1632-1642

1642-1657

1658-1669

The golden years

Hurtling towards disaster

Alone with his work

Index

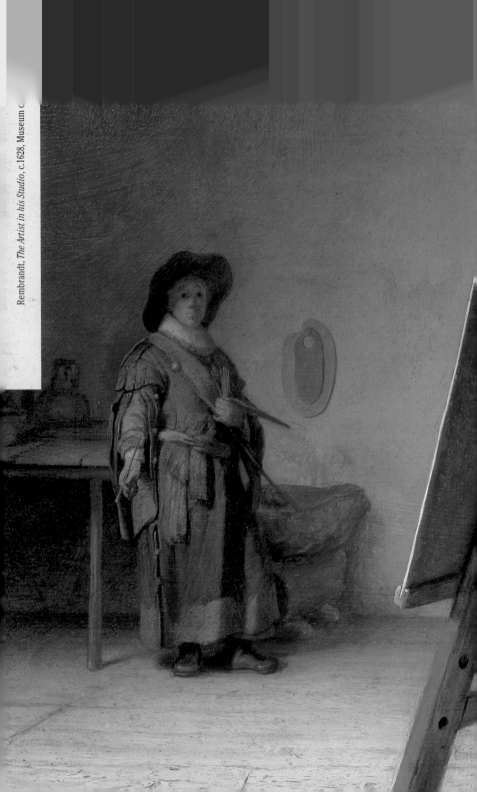

Holland: the pride and prospects of a new nation

At the end of a long, bitter war against the Spanish Empire, the seven United Provinces of the northern Low Countries (Holland being just one of these) were finally able to secure their independence. Led initially by the brave *stadhouder* William of Orange, the protestant provinces broke away from the southern regions, which would go on to become Belgium. Within the space of just a few years, this tiny territory, now known as the Netherlands, with its flat landscape dotted with windmills along the canals, grew into one of the most powerful economies in Europe. Before long, the Dutch people were able to share a sense of national pride and found much to unite them: the Dutch language, widely promoted thanks to intensive literacy campaigns; the Calvinist religion, which welcomed Catholic and Jewish minorities in a spirit of tolerance; a regularly organized calendar in which festivals and penances were alternated; a love of family; and a widespread, unparalleled prosperity that was open to everyone. Free of ecclesiastical privileges and with no court or aristocracy as such, 17th-century Holland can be regarded as the first modern capitalist democracy.

■ Dating from about 1660, *The Linen Closet* (above) by Pieter de Hooch and *The Happy Family* (below) by Jan Steen illustrate different sides of life in "Golden-Age" Holland. In one, family life is governed by order and cleanliness, and, in the other, we see the debasement – and enjoyment – of a family in which adults set a bad example. Both works are in the Rijksmuseum, Amsterdam.

■ This popular allegorical picture from the second half of the 16th century satirizes the "Dutch cow", being ridden by the King of Spain, Philip II.

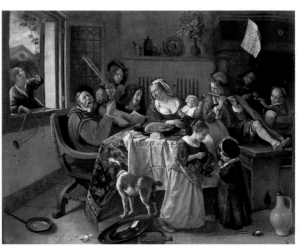

■ Gerard Houckgeest, *Funerary Monument of William the Silent at Delft*, 1651, Mauritshuis, The Hague. William of Orange (The Silent), assassinated in 1584, is considered the father of modern Holland and the hero of the rebellion against the Spanish. His monumental mausoleum, frequently visited by the Dutch people, also features in many other commemorative works.

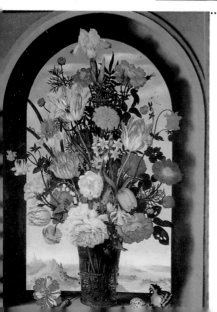

Tulipomania

This painting by Ambrosius Bosschaert (c.1618, Mauritshuis, The Hague) shows several fancifully shaped tulip varieties in a range of different colors. Imported from Constantinople and the Levant at the end of the 16th century, these precious bulbs were the object of a trade that became increasingly widespread. From the flower beds of aristocratic gardens, tulips gained rapidly in popularity and became the focus of colossal speculative dealing. The collapse of the tulip market in 1638 had many serious repercussions, ruining dozens of small savers and putting the Dutch economy in crisis.

A family of craftsmen on the banks of the Rhine

Weddesteeg is a road close to Leiden's city walls. Here, on July 15, 1606, the eighth and penultimate son of a miller – the owner of a windmill on the banks of the Rhine and thus known as "Van Rijn" (of the Rhine) – was born. Catholic in origin, the family had converted to Calvinism. The boy's parents, Harmen and Cornelia, chose the unusual name of Rembrandt for their newborn infant. They may have been hoping for a girl, whom they could have named after the maternal grandmother, Remigia. Married for 17 years at the time of the birth, Rembrandt's parents were no longer young; indeed, he always saw them as weighed down by a biblical agedness. According to tradition, the patronymic Harmenszoon ("son of Harmen") was added to the child's name, together with the surname Van Rijn. The effect was high-sounding, but the artist's origins were firmly rooted in the working class, as is evidenced by the trade plied by his brothers: the eldest was a miller, like his father, another became a baker, like his maternal grandfather, and a third a cobbler. The family was nevertheless fairly comfortably off, and could afford to educate the young Rembrandt at the Latin School in Leiden.

■ Rembrandt, *Portrait of the Artist's Mother*, c.1628, etching. Rembrandt's parents were no longer young at the time of his birth and the artist typically portrays them as elderly and grave figures, rather like biblical characters.

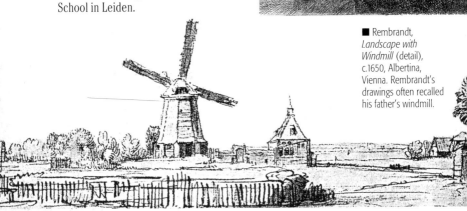

■ Rembrandt, *Landscape with Windmill* (detail), c.1650, Albertina, Vienna. Rembrandt's drawings often recalled his father's windmill.

■ Rembrandt, *The Artist's Father*, 1630, watercolor drawing, Ashmolean Museum, Oxford. This is the only identified portrait of Rembrandt's father, although his face appears in several of the artist's paintings.

HARMAN. GERRITS.

■ This map of Leiden, engraved by Pieter Bast and printed in 1660, shows the historical town centre surrounded by its protective walls and marked out by the Rhine flowing through it. In the area to the bottom left (circled) is the windmill that belonged to Rembrandt's family. The house where he was born was close by.

■ This 17th-century drawing, housed in Leiden's historical archive, shows the city's Latin School, where Rembrandt was educated. Although he cannot be described as an intellectual, Rembrandt nevertheless had a cursory knowledge of the classics and great respect for books and the printed word.

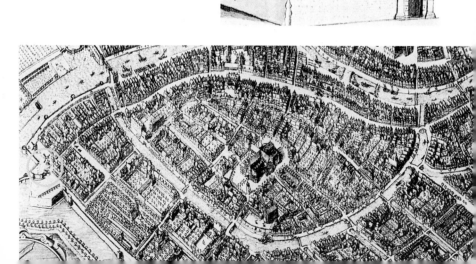

BACKGROUND

Leiden's "fine painting" and historical works

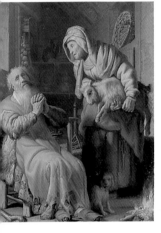

■ Rembrandt, *Anna Accused by Tobit of Stealing the Kid*, 1626, Rijksmuseum, Amsterdam. This is an early, sharply observed biblical work.

T he city of Leiden was one of the most important cultural centres in Holland during the "Golden Age". Roughly 40 kilometres from Amsterdam, it is held in great affection by the entire country, because of the extreme bravery with which it endured the Spanish siege in 1574. The city is criss-crossed by the canals formed by the Old Rhine, one of the two branches into which the great river divides once it reaches its intricate delta. In the early 17th century, Leiden boasted about 40,000 inhabitants and housed a dozen or so windmills, including the one belonging to the Van Rijns. The city's wealth lay mainly in its flourishing textile businesses and in the lively trade of its market, but it was above all a cultural city, with a renowned university and an impressive background in the humanities and the arts. It was in Leiden that a notable 16th-century artistic school developed, arguably the most important in Holland. Its key artist, Lucas van Leyden, was, like Rembrandt, a great painter and a skilled engraver, whose work was admired by Dürer. His elegant art, meticulous in the reproduction of detail and inspired by traditional religious themes, remained a specific point of reference for more than a century among Leiden's artists and collectors. It led to the so-called fine painting, the style adopted by the young Rembrandt.

■ Rembrandt, *David Presenting Saul with the Head of Goliath*, 1625, Kunstmuseum, Basle. The splendor of Lucas van Leyden's engravings, the richness of Venetian 16th-century style, and the precious sparkle of gold all inspired Rembrandt to paint lesser-known biblical episodes and developed his taste for sumptuous narrative scenes.

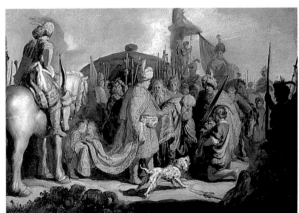

Lucas van Leyden

The main representative of the Leiden School, Lucas van Leyden was born in about 1494. A precocious engraver, it was as early as 1510 when he revealed his skill in pairing traditional sacred themes with subjects and characters drawn from contemporary, everyday farming life, anticipating the future development of Dutch art. Even his youthful works show meticulous attention to detail. By 1521, he was an international celebrity and met Dürer at the height of the northern Renaissance. After this date, van Leyden's work became more solemn. He died in 1533.

■ Lucas van Leyden, *The Adoration of the Magi*, 1513, engraving. Lucas van Leyden's Renaissance prints were widespread in Europe. Rembrandt owned a collection of them.

■ Isaac van Swanenburgh, *Aeneas in the Underworld*, Stedelijk Museum De Lakenhal, Leiden. Rembrandt's first teacher was an exponent of the local school and his style was linked to the tradition of Bosch. Besides painting, he also produced works in the applied arts, such as tapestries, and stained glass. Rembrandt's apprenticeship with Van Swanenburgh was workmanlike: he learned his craft rather than "art". It provided him with the opportunity for his first contact with Italian art, whose masterpieces he studied although he never visited the country.

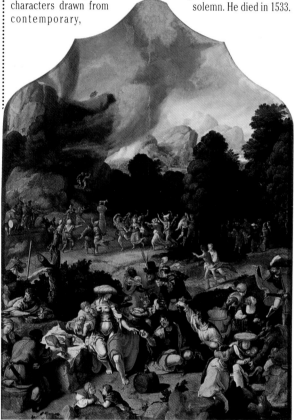

■ Lucas van Leyden, *The Adoration of the Golden Calf*, central panel of a triptych, c.1530, Rijksmuseum, Amsterdam. This late work reveals an almost pre-Mannerist development in the art of the Dutch master.

A beginner's options

Duringthe 1620s, painters throughout Europe were alerted to the news emanating from Rome: the revolutionary art of Caravaggio, who achieved astonishingly realistic effects through the use of diagonal light, corresponded with a rapid expressive development of the Baroque style and the result was a lavish tour de force of color and animation. Dutch art, too, came under the Italian influence, but the peculiarities of the local art market (which was aimed mainly at the bourgeoisie rather than the aristocracy or the Church) necessitated alternative solutions. Rembrandt's artistic training took place against this background of stimulus and debate. On the one hand, there was great historical painting, inspired by Italian models and the Antwerp school and dominated by Rubens; on the other, the singularly Dutch predilection for small, elegantly executed paintings, destined to be hung in ordinary houses and not in princely collections. Other factors were the Calvinist religion and a considerable Jewish presence, which fostered personal reflections on the Bible.

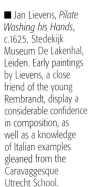

■ Jan Lievens, *Pilate Washing his Hands*, c.1625, Stedekijk Museum De Lakenhal, Leiden. Early paintings by Lievens, a close friend of the young Rembrandt, display a considerable confidence in composition, as well as a knowledge of Italian examples gleaned from the Caravaggesque Utrecht School.

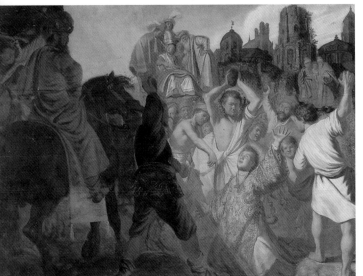

■ Rembrandt, *The Martyrdom of St Stephen*, 1625, Musée des Beaux-Arts, Lyons. Dated and monogrammed "R f" (Rembrandt *fecit*), this medium-sized painting on panel is the first work that can be attributed with certainty to the artist, easily recognizable as the elegant, precious style of the Leiden School. The melodramatic gestures and the classical style of the faces, however, hark back to the period that Rembrandt spent in the workshop of Pieter Lastman.

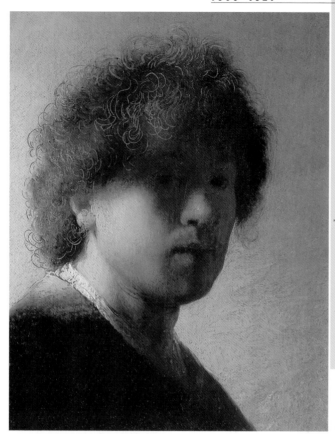

■ Rembrandt, *Self-portrait*, c.1628, Rijksmuseum, Amsterdam. Because so many copies exist, it is difficult to establish just how many self-portraits Rembrandt produced. This is a "private" work, free in expression and consummately original in technique. To pick out the light on the the curly hair, Rembrandt dotted the canvas with the wooden tip of his paintbrush.

■ Hendrick Terbrugghen, *King David Playing the Harp*, c.1625, Muzeum Narodowe, Warsaw.

The Utrecht School

In the early decades of the 17th century, Utrecht was, perhaps, the foremost artistic centre of the United Provinces. In Calvinist Holland, it remained mostly Catholic and the city's painters drew their inspiration directly from Caravaggio. The leading figure was Gerrit van Honthorst, who promoted a taste for nocturnal scenes. Equally important artists included Hendrick Terbrugghen and Gerard Ter Borch, who applied the Caravaggesque style to their paintings of scenes drawn from everyday life.

The Parable of the Wealthy Simpleton

Signed and dated 1627, this small but important early work is housed in the Staatliche Museen, Berlin. The figure, an old, bespectacled man examining a coin against the light of a candle, has been interpreted in different ways.

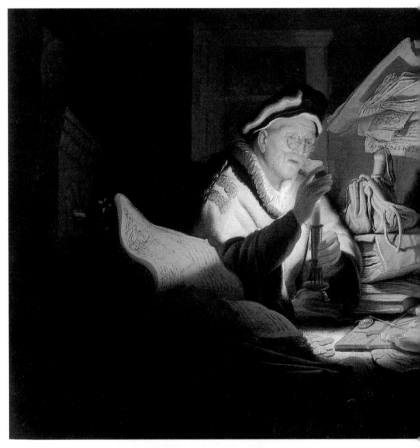

■ A fundamental precedent for the realistic interpretation of religious themes was set by the *Calling of St Matthew*, painted in 1600 by Caravaggio for the church of San Luigi dei Francesi in Rome.

16

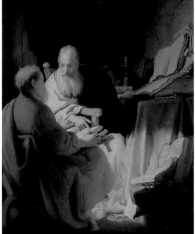

■ Rembrandt, *Two Scholars Disputing St Peter and St Paul in Conversation)*, c.1628, National Gallery of Victoria, Melbourne. The books, candlestick, and light are borrowed from Caravaggio.

■ Hendrick Terbrugghen, *Calling of St Matthew* (detail), c.1620, Musée des Beaux-Arts, Le Havre. The best-known exponent of the Utrecht School, Terbrugghen introduced many Caravaggio-inspired figures into his work. Rembrandt's old man in *The Parable of the Wealthy Simpleton* has many affinities with this tax collector, in turn influenced by Caravaggio.

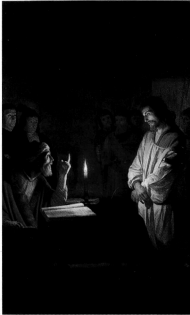

■ Gerrit van Honthorst, *Christ Before the High Priest*, c.1617, National Gallery, London. The candlelit scene was one of the effects most favored by early 17th-century artists and collectors throughout Europe. Gerrit van Honthorst produced some remarkable examples. Rembrandt thus cut his teeth on a difficult technique that was very much in vogue at this time.

BACKGROUND

The influence of Lastman

Rembrandt's artistic training ended in 1624 with a six-month stay in Amsterdam with the artist Pieter Lastman. The high quality of Lastman's work was in marked contrast to the artists with whom he had previously come into contact. Lastman was an established artist who was able to exercise a decisive influence on his talented pupil. Having returned to Amsterdam from Italy in 1610, Lastman was inspired by the international environment of Roman painting in the early 17th century. He was a typical historical painter, producing religious and mythological scenes destined for a public of connoisseurs. His style, which nowadays appears to be too serious and pompous, appealed to the Italianate taste of a section of the Amsterdam public. Rembrandt studied Lastman's work in detail, patiently copying his subjects and compositions. He mastered the art of precise draughtsmanship, the wide-ranging scene, and the reference to ancient models, but added to them a dynamism and feeling that Lastman's works never achieved.

■ Pieter Lastman, *The Angel and the Prophet Balaam*, 1622, Private Collection, New York. between Rembrandt and Lastman can be illustrated by comparing this work by the older master (below) with the interpretation by his younger pupil (left). The main episode, with the prophet beating the ass and the animal's reaction, is very similar. In Lastman's painting, the angel remains essentially apart from the action and the light of an Italian landscape illuminates the work; in Rembrandt's version, the angel is more directly involved in the scene, making it much more dramatic.

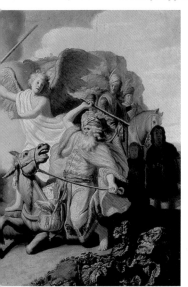

■ Rembrandt, *The Angel and the Prophet Balaam*, 1626, Musée Cognacq-Jay, Paris.

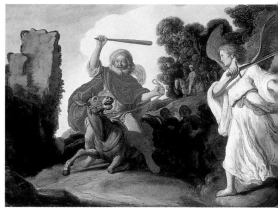

■ Rembrandt, *Susanna Surprised by the Elders*, drawing, Kupferstichkabinett, Berlin. This drawing, executed with a confident technique, is a faithful reproduction of one of Lastman's most important works. A comparison between the master's original version and the pupil's copy reveals the detail with which Rembrandt studied Lastman's paintings. It also highlights the weakness of the original composition; Rembrandt widens the space between the figures, giving the scene a dramatic sweep that his teacher was unable to achieve.

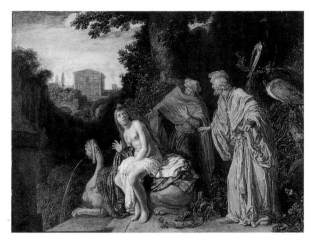

■ Left: Pieter Lastman, *Susanna Surprised by the Elders*, 1614, Staatliche Museen, Berlin.

■ Below: Pieter Lastman, *The Baptism of the Ethiopian Eunuch*, 1623, Staatliche Museen, Karlsruhe. This unusual theme also inspired an early work of the same title by Rembrandt (right), painted in 1626 and now in the Museum Catharijne Convent, Utrecht.

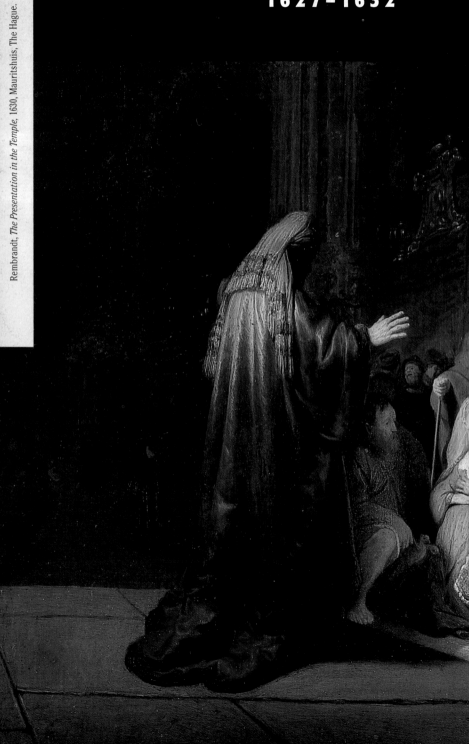

Rembrandt, *The Presentation in the Temple*, 1630, Mauritshuis, The Hague.

The beginning of
a glorious career

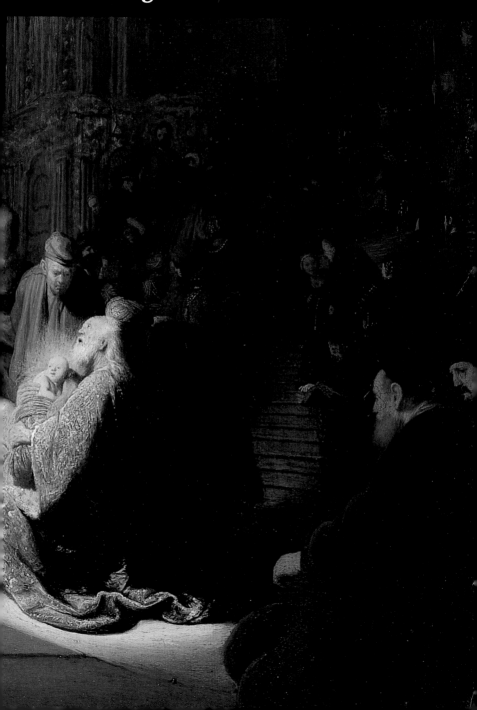

A partnership
with Jan Lievens

■ Rembrandt, *The Apostle Paul in Prison*, 1627, Staatsgalerie, Stuttgart. The sword leaning against the bed (an incongrous detail in a prison cell) is the traditional attribute that identifies St Paul.

Once he had completed his training with Lastman, Rembrandt returned to Leiden, now with professional prospects. At the age of 19, his destiny was clear. He set up a joint studio with Jan Lievens, another novice painter from Leiden, who was a year younger than Rembrandt and had also been a pupil of Lastman's. The two young artists worked closely together, their style and subject-matter almost playfully overlapping. They used the same models, painted portraits of each other, and competed in the painting of similar themes. Both introduced Italianate elements into their work (learned from Lastman and from their common admiration for the Utrecht artists), in the "fine painting" tradition of Leiden. Success, for the time being, was confined to their native city, but more widespread recognition for the pair would not be long in coming.

■ Rembrandt, *The Noble Slave*, 1632, Metroppolitan Museum of Art, New York. During the years he spent in the studio shared with Lievens, Rembrandt developed a taste for the exotic, the unusual, and the picturesque. A comparison between this work and Lievens' oriental figure (left) reveals significant differences: Lievens' is composed and illustrative, while Rembrandt's is a much livelier interpretation.

■ Jan Lievens, *An Oriental*, c.1628, Sanssouci Castle, Potsdam. Lievens' work differs from Rembrandt's in its heavier volumes, which are more strongly defined by the shade.

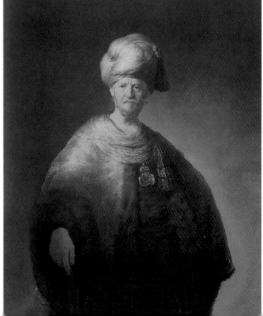

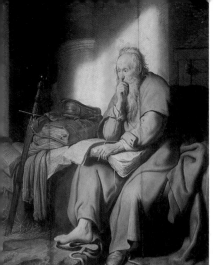

■ Jan Lievens, *The Apostle Paul Writing the Epistle to the Thessalonians*, c.1629, Kunsthalle, Bremen. The two artists, who were themselves still very young, often painted elderly figures, expressively marked with wrinkles and with long, unkempt beards.

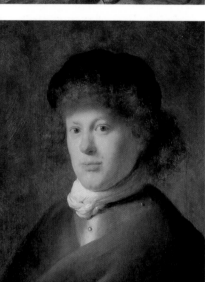

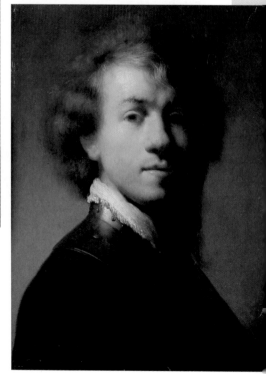

■ Jan Lievens, *Portrait of Rembrandt*, c.1629, Rijksmuseum, Amsterdam. The most unusual feature of the partnership between the two artists is their creation of "crossed" portraits, a game in which they swapped identities.

■ Rembrandt, *Self-portrait*, c.1629, Mauritshuis, The Hague. The piece of armor is deceptive: Rembrandt had no connection with any garrison, but the dignity of his stance reflects the pride of the young Dutch nation.

1627–1632

The Prophet Jeremiah Mourning over the Destruction of Jerusalem

Signed and dated 1630, this painting is housed in the Rijksmuseum, Amsterdam. The prophet Jeremiah laments the destruction and fire of Jerusalem, caused by King Nebuchadnezzar, who banished the Jews to exile in Babylonia.

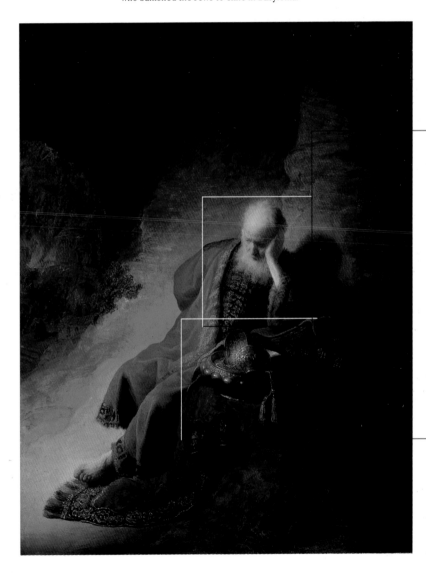

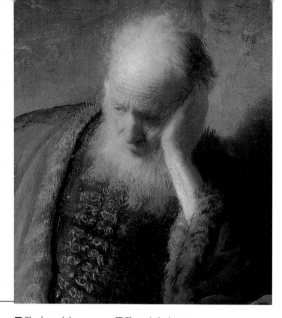

■ Below: Rembrandt, *Old Man Sleeping By the Fire*, 1629, Galleria Sabauda, Turin. Rembrandt had painted this similar figure a year earlier, but this work has none of the dramatic enormity of Jeremiah's situation.

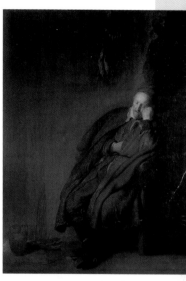

■ The face of the aged prophet presents features similar to Rembrandt's father Harmen van Rijn, who died shortly before this work was painted. There are no certain portraits of Harmen, however, although he appears in some works.

■ The painting's most unusual feature is the lavish and elaborately detailed goldwork. Rembrandt skilfully reproduces the precious metal, which glows with the reflection of what appears to be the fire ravaging the city of Jerusalem.

■ Jan Lievens, *Job on the Dungheap*, 1631, National Gallery of Canada, Ottawa.

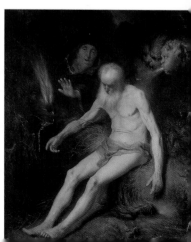

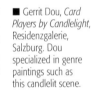

BACKGROUND

Rembrandt's first pupil: Gerrit Dou

In February 1628, Rembrandt took on his first pupil, his fellow townsman Gerrit Dou, who was only 15 at the time. The acquiring of pupils (who paid a not inconsiderable sum to their teacher) was a clear sign of the artist's standing. Dou's arrival coincided with Rembrandt's first economic success: a painting that he transported on foot from Leiden to Amsterdam was sold in the capital for the more than respectable sum of 100 guilders. Dou remained in the workshop until Rembrandt moved to Amsterdam in 1632. He went on to become a master in his own right, and the most typical representative of the *fijnschilders* ("fine painters") of the Leiden School. He also carried out a civic role in his native city, being personally responsible for the founding of a guild of painters (1648). Born into a family of artists (his father was a glass engraver) and himself an artist of great skill and distinctive style, Dou concentrated exclusively on creating very small paintings, which he executed with a flawless technique and in minute detail. The years he spent with Rembrandt were fundamental to his artistic development, and he also painted some works in conjunction with his teacher.

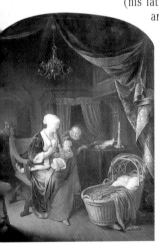

■ Gerrit Dou, *The Young Mother*, Staatliche Museen, Berlin. Here, the realistic details are handled with a minute precision reminiscent of Flemish painting.

■ Gerrit Dou, *Card Players by Candlelight*, Residenzgalerie, Salzburg. Dou specialized in genre paintings such as this candlelit scene.

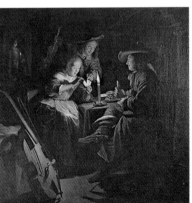

■ Gerrit Dou, *Interior with Woman Eating Barley Broth*, c.1632, Private Collection. The model for the woman in profile in this youthful work is Rembrandt's mother, who would pose for her son's pupils.

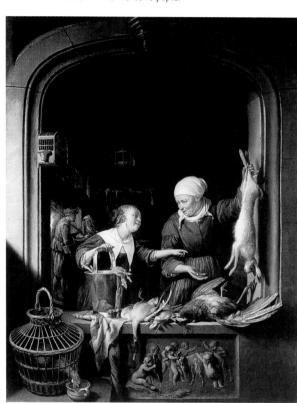

■ Gerrit Dou, *A Poulterer's Shop*, c.1670, National Gallery, London. Some of Dou's paintings feature exuberant, almost *trompe l'oeil* still lifes in the foreground, rendered with flourish and skill.

■ Gerrit Dou, *Self-portrait with Easel*, Private Collection.

Obsessive behaviour

According to some scholars, Dou's psychological make-up presents some interesting peculiarities. As we can see from his paintings, the artist was obsessed with cleanliness. Contemporary sources report a mania for keeping his studio austerely clean, to the point of restricting visits from outsiders to an absolute minimum. He was prone to outbursts of rage over what he saw as the "contamination" introduced by laborers or tradesmen who were less than scrupulously clean. The fear that there could be dust in his studio would make him stop work for days at a time. Unsurprisingly, his obsession meant that he could not take a wife. On the other hand, Dou would set out his palette, brushes, and other equipment with impressive care and perfect order. The object of much collector and academic interest, he painted a limited number of works, slowly, with an exasperating precision.

A turning point: the role of Constantijn Huygens

■ Above right, Jan Lievens, *Constantijn Huygens*, 1628–29, Rijksmuseum, Amsterdam.

■ This 17th-century drawing of The Hague shows, in the foreground, Huygens' house, and the Mauritshuis, built for John Maurice, Count of Nassau-Siegen, and now the Royal Museum of Painting.

The turning point in Rembrandt's career and that of his partner Lievens came with a visit to their studio by Constantijn Huygens in 1628. Secretary to Prince Frederick Henry of Orange and one of the most cultured and influential figures in Holland, he was an experienced diplomat and tireless traveller, and a moderately talented poet. His opinion, in matters artistic, carried considerable weight. In his autobiography, published in 1631, he describes a visit to two young painters of humble origin who were virtually unknown. The artists made a deep impression on him. Huygens found Lievens the more open-minded, and deeply inventive, of the two, whereas Rembrandt had a superior elegance of touch and was able to communicate intense emotion in his work. The young artists' destiny was mapped out by the visit. Huygens commissioned Lievens to paint his portrait and Rembrandt to paint his brother's. He followed the career of both artists for some years, assisting Lievens in his move to England and securing princely commissions for Rembrandt. For a while, he acted almost as their agent, submitting their works to international collectors. A fervent supporter of Dutch art and culture, Huygens stressed that although neither Rembrandt nor Lievens had ever been to Italy, their work stands on a par with the great masters of the past.

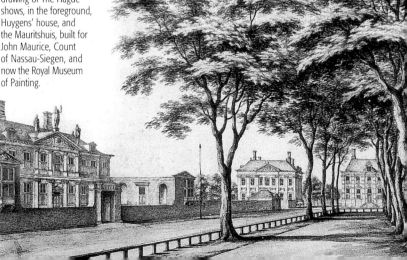

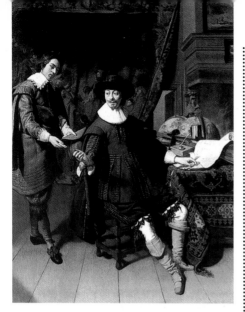

A sophisticated thinker

The United Provinces ambassador to Venice and, later, London, polyglot, scholar of astronomy, translator, and eminent man of letters, Huygens offers us a perfect example of the autonomy of 17th-century Holland. Highly skilled in recognizing and developing talent in the young, he inspired Rembrandt to focus on religious and mythological themes, such as this (below), and encouraged his own son Christiaan to study science. Christiaan Huygens went on to invent the pendulum clock, and his theories helped Newton to formulate his law of gravitation.

■ Thomas de Keyser, *Constantijn Huygens and his Clerk*, 1627, National Gallery, London. This illustrates the social prestige enjoyed by Huygens.

■ Right: *The Abduction of Proserpine* (1632, Staatliche Museen, Berlin) was painted by Rembrandt at the suggestion of Huygens.

■ Opposite: These two small portraits were painted by Rembrandt as a pair in 1632. The subjects are Constantijn's brother Maurits Huygens (above) and his friend the artist Jacob de Gheyn III (below). They are housed in the Kunsthalle, Hamburg, and the Dulwich Picture Gallery, London, respectively. They mark the beginning of the long and profitable friendship the artist shared with Huygens.

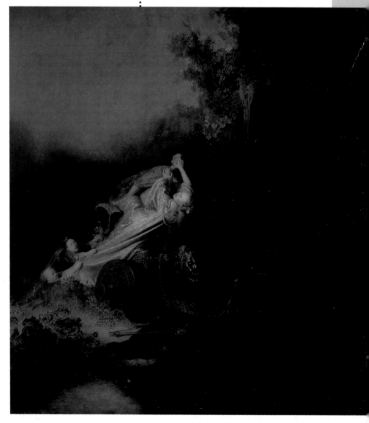

Family members as models

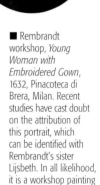

All his life, Rembrandt painted his relatives, choosing particular moments, poses, clothes, and hairstyles. The memorable series of paintings depicting his wife Saskia, arguably the most intense sequence of paintings ever to be devoted by an artist to his companion, was preceded and followed by countless others. Family members are usually shown as "characters", almost as though specializing in a few specific roles in a universal theatre, so works in which they feature can usually be viewed as interpretations rather than portraits. The artist's mother is an infirm, devoted old woman, his father a picturesque, gruff old man, his sister Lijsbeth a large, comely, and rather vacant-looking blonde, and his son Titus a child who discovers the beauty and wonder of the world for the first time. Saskia warrants a separate analysis. Her painted and engraved portraits tell the story of their marriage, from the joy of the early years to its dramatic conclusion.

■ Rembrandt workshop, *Young Woman with Embroidered Gown*, 1632, Pinacoteca di Brera, Milan. Recent studies have cast doubt on the attribution of this portrait, which can be identified with Rembrandt's sister Lijsbeth. In all likelihood, it is a workshop painting

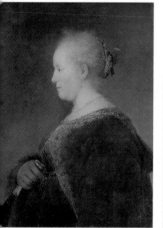

■ Rembrandt, *Old Woman in Prayer* (*"Portrait of the Artist's Mother"*), 1630, Rresidenzgalerie, Salzburg. Rembrandt's mother, unnaturally aged and wrinkled, acted as a model for her son on many occasions, becoming the very image of old age.

■ Rembrandt, *Young Woman Holding a Fan*, 1632, Statens Konstmuseer, Stockholm. The girl portrayed is almost certainly the artist's younger sister Lijsbeth.

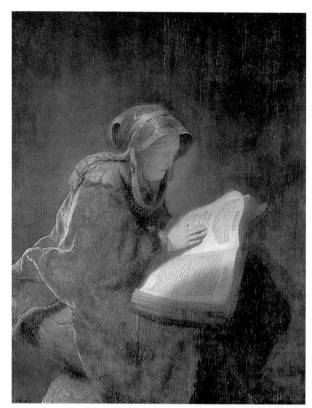

■ Rembrandt, *The Artist's Mother as the Biblical Prophetess Hannah*, 1631, Rijksmuseum, Amsterdam. The light of knowledge, reflected in the yellowing pages of the large tome, suffuses the entire picture with penetrating impact. The trepidation with which the old woman leafs through the pages of the Bible imbues the painting with a solemn awareness of the Word.

■ Rembrandt, *Old Man in a Fur Hat* (*"Portrait of the Artist's Father"*), 1630, Tiroler Landesmuseum, Innsbruck.

Portraits or character studies?

Rembrandt's repeated portrayal of his parents reveals a curious side to his role as a portraitist. These paintings are not strictly speaking portraits in the accepted sense of the term, that is, realistic images of recognizable figures, but rather character studies of a more psychological nature. Particular facial expressions, unusual features, hairstyles, exotic hats or clothing are used to echo the sitters' quirks. These character studies were called *tronijes* in Dutch and were highly sought after. Rembrandt executed a large number of these works, both painted and engraved.

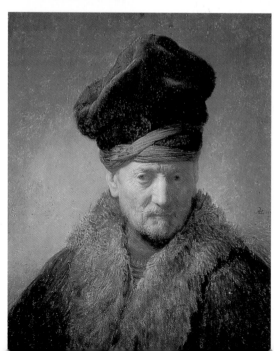

1627–1632

Judas Returning the Thirty Pieces of Silver

In a private collection in England, this work dates from 1629. Constantijn Huygens praised its expressive power and the use of light, comparing it to the best of antiquity.

■ The contrite expression and the exaggerated pose of Judas are of clear theatrical derivation. From his earliest works, Rembrandt displayed a keen interest in the world of the theatre.

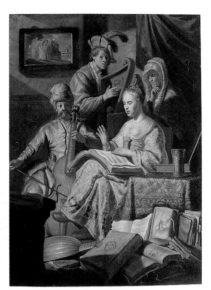

■ Rembrandt, *Self-portraits with Grimaces*, 1628–30. Here, the study of facial expressions almost culminates in caricature. Using a mirror, Rembrandt distorted his own features in order to achieve violent effects.

■ Rembrandt, *Concert in Biblical Garb*, 1626, Rijksmuseum, Amsterdam. Even in his early works, Rembrandt places his figures in evocative settings, with precious fabrics, great tomes, carefully painted objects, sumptuous costumes, and a profusion of gilded elements. The artist would collect assorted objects to use as props in his work. This taste for opulence, which can be traced back to the Leiden tradition, characterized his entire output.

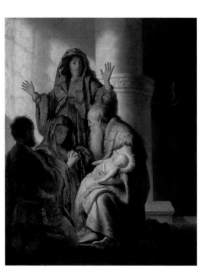

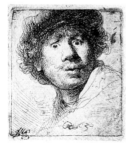

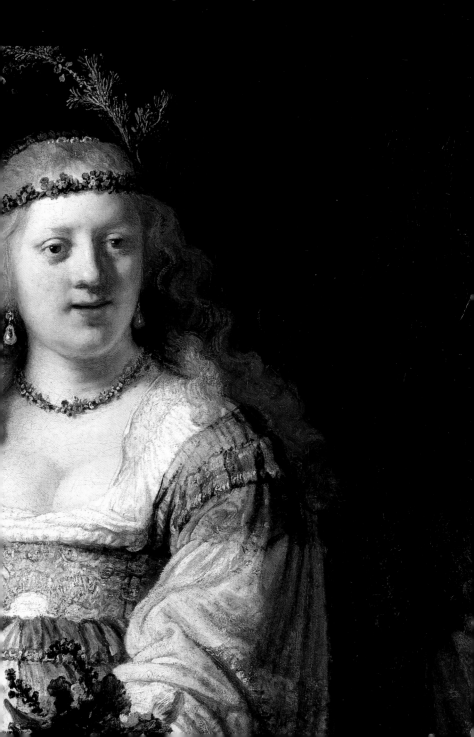

The golden years

1632–1642

The move to Amsterdam

Huygens' praise, the increasingly frequent visits from art lovers, his first economic successes, and his gradual detachment from the family environment after the death of his father in 1630 all combined to give Rembrandt a bold new idea. After meeting the Amsterdam art dealer Hendrick van Uylenburch, in 1631, Rembrandt invested the large sum of 1,000 florins in the trading of works of art. Van Uylenburch had many useful and influential contacts and an affluent, demanding clientele that was particularly interested in portraits. Recognizing Rembrandt's ambition, he offered him a particularly advantageous deal. The young artist left Leiden for good in July 1632 and moved to Amsterdam, the main mercantile and artistic centre in the country. Van Uylenburch offered him lodgings and a studio in an elegant part of the capital and acted as intermediary between Rembrandt and his clients. For a while, Rembrandt had to concentrate exclusively on portrait painting, in order to make his name known among the circle of collectors, art lovers, and Holland's wealthiest purchasers of works of art.

■ Rembrandt, *View of the River Amstel from the Blauwbrug, Amsterdam*, Rijksmuseum, Amsterdam. In his rare drawings of Amsterdam, Rembrandt records minor details and impressions of the city.

■ Right: Rembrandt, *Jesus and His Disciples in the Storm*, 1633, Isabella Stewart Gardner Museum, Boston. Following his move to Amsterdam, Rembrandt alternated between portraits and sought-after paintings of biblical or historical subjects. These were skilfully executed with the refined style and detailed structure of the Leiden School.

■ Rembrandt, *The Holy Family*, c.1634, Alte Pinakothek, Munich. Throughout his long career, Rembrandt painted religious works. In Calvinist Holland, such paintings were not intended for churches, but for collectors and private devotion. Rembrandt thus handles religious themes in both a grandiose, elegant manner and in a domestic, everyday context.

■ Rembrandt, *Self-portait with Wide-brimmed Hat*, 1631, engraving. Once he became successful, the artist's wardrobe became more elaborate and his pose more confident.

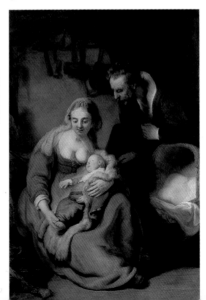

■ Jan van der Heyden, *The Internal Canals of Amsterdam*, Mauritshuis, The Hague. Thanks to his pioneering use of a camera obscura, van der Heyden has left us the most precise views of the Amsterdam townscape.

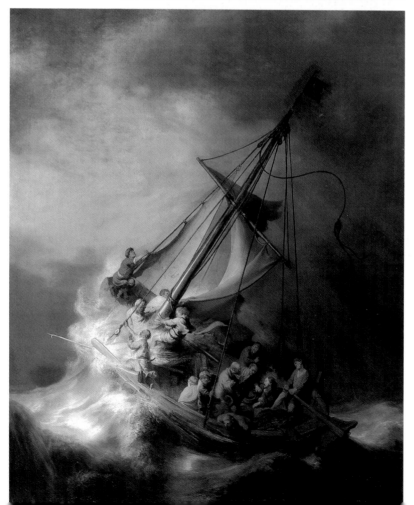

BACKGROUND

Merchants, customers, and intellectuals

■ Rembrandt, *Jan Uytenbogaert, the Gold Fisherman,* 1639, engraving. This prestigious figure had a clearly defined role for Rembrandt: as tax collector general, he had to pay him the fees due to him for the paintings he produced for the court at The Hague.

At the time of Rembrandt's move to Amsterdam, the city was enjoying a period of full economic, urban, and social development. The capital of an increasingly vast colonial empire (Nieuw Amsterdam was founded in 1626, subsequently ceded to the English and renamed New York), it charmed and fascinated its visitors. The thriving commercial port was packed with ships, and shops and markets sold goods from all over the world, with an opulence and choice that had no equal anywhere in Europe. The layout of the city was extended and made more regular through the creation of three wide concentric canals flowing through the old historical town centre. Studded side by side along one of these, the *Herengracht*, were beautiful stone and brick edifices, with the characteristic terraced façades, which were the comfortable dwellings of the wealthier merchants and professionals, many of whom were Rembrandt's customers. New churches, such as the Westerkerk, were built in a dignified Baroque style, as was the Stock Exchange, particularly interesting for its architectural features and at the heart of the city's commercial activity, dominated by the powerful East and West India companies.

■ Right: Cornelis de Man, *Group Portrait in the Chemist's House,* Muzeum Narodowe, Warsaw. Scientific activity abounded in Amsterdam after Descartes moved to the city in 1628.

■ Rembrandt, *Maarten Soolmans* and, right, *Oopjen Coppit*, 1634, Rothschild Bequest, Paris. Rembrandt gave the full-length portraits of the 1630s a sumptuous treatment. Men and women sport lace, bows, feathers, and puff sleeves, in works that hold their own, in terms of their finery, with the more high-flown portraits of the period, such as those by Van Dyck. The exuberance of Rembrandt's painting during this phase mirrors the success enjoyed by Frans Hals, the most popular Dutch portrait painter of this time.

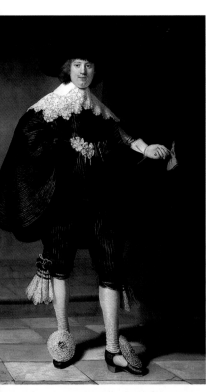

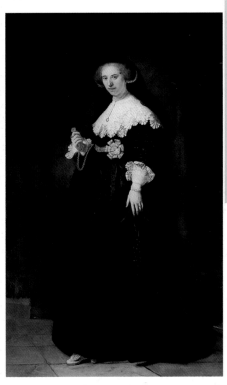

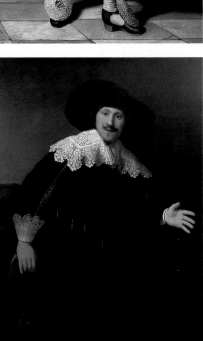

■ Rembrandt, *Portrait of a Man Rising from a Chair*, 1633, The Taft Museum, Cincinnati. In some cases, Rembrandt indulges in more dynamic, intimate poses than those allowed under the rules set out for official portraiture.

The Anatomy Lesson of Dr Tulp

Housed in the Mauritshuis, The Hague, this fascinating and lively group portrait was commissioned in 1632. It was originally exhibited at the headquarters of the surgeons' guild in Amsterdam.

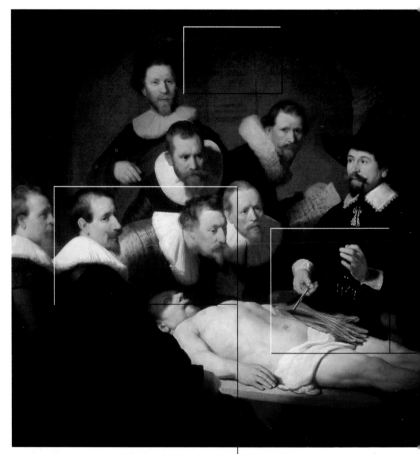

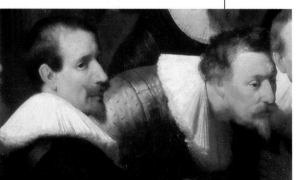

■ The seven figures gathered around the dissecting table are not medical people, but city officials. Their expressions reveal both a scientific interest and a justifiable repulsion.

■ Rembrandt's signature can be seen on the wall in the background and hints at his new-found awareness of his artistic merit. During his early years, the artist signed himself merely RHL (Rembrandt Harmenszoon of Leiden), or Rembrandt van Rijn. From 1632, however, he signed himself only with his forename, occasionally followed by the letter "f" (for the Latin *fecit*). In this way, the artist was following in the tradition of Italian masters of the 16th century, Titian, Raphael, Leonardo and Michelangelo.

■ Dr Tulp is dissecting the left arm of the corpse, exposing the tendons. With his left hand, he skilfully demonstrates the contractions and movements of the fingers. The anatomic precision indicates direct study on Rembrandt's part.

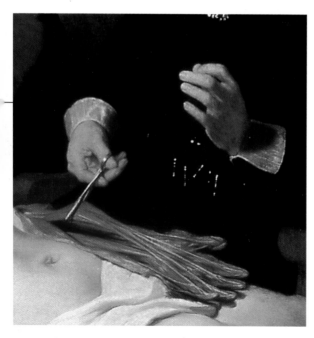

Saskia

Rembrandt met the twenty-year-old Saskia at the home of Hendrick van Uylenburch, his associate and dealer. She was a close relative of van Uylenburch. On the death of her father, who had been burgomaster of Leeuwarden, she had left the province of Friesland in order to settle in Amsterdam. A love affair developed between the young artist and the cultured, florid, and rather timid girl. Saskia and Rembrandt, defying the guarded reaction from her tutor and relatives, became officially engaged on June 5, 1633. Arrangements for the marriage were made, with Rembrandt's mother dithering for a long time before giving her consent. Finally, on July 22, 1634, Rembrandt and Saskia were married, having chosen to return to Saskia's native Friesland for the wedding. Rembrandt and Saskia enjoyed a mutually affectionate relationship, based on imagination, fun, and sensual fulfilment. For Rembrandt, the miller's son, the marriage also involved a considerable rise in his social status.

■ Rembrandt, *Saskia Wearing a Veil*, 1633, Rijksmuseum, Amsterdam. Saskia, from a considerably affluent family, brought a dowry of no less than 40,000 guilders to the marriage. Some of her relatives were envious of the large sum and would later accuse Rembrandt of squandering it.

■ Rembrandt, *Saskia in a Hat*, c.1635, Staatliche Museen, Gemäldegalerie, Kassel.

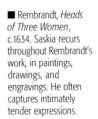

■ Rembrandt, *Heads of Three Women*, c.1634. Saskia recurs throughout Rembrandt's work, in paintings, drawings, and engravings. He often captures intimately tender expressions.

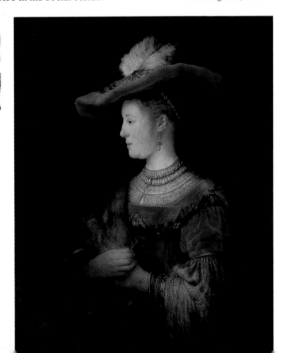

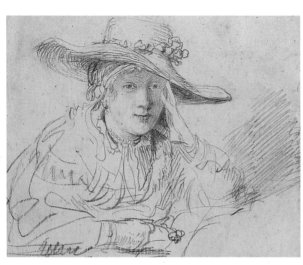

■ Rembrandt, *Saskia in a Straw Hat*, 1633, Kupferstichkabinett, Berlin. At the side of this drawing, Rembrandt wrote: "This is a portrait of my fiancée at the age of twenty-one, three days after our engagement".

■ Rembrandt, *Saskia as Flora*, 1634, State Hermitage Museum, St Petersburg. Here, the pose and clothing suggest pregnancy: in 1635 Saskia gave birth to a boy, Rombertus, who only lived two months.

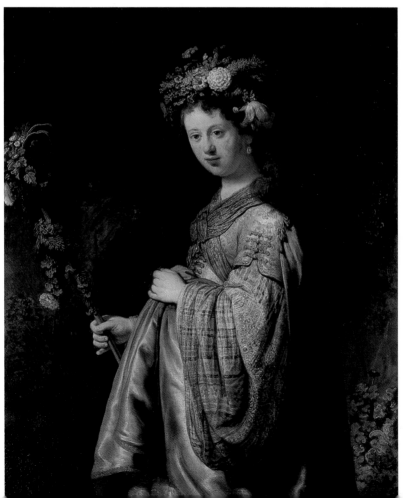

LIFE AND WORKS

A rapid ascent

Thanks to his successful marriage and the consistently high fees he earned as a painter and engraver, Rembrandt became a wealthy man almost overnight, on a par with highly respected professionals and members of high society. In 1635, at the age of 29, he was able to move out of van Uylenburch's house and take up residence in an elegant dwelling on the banks of the Amstel. At the same time, he rented a large warehouse and converted it into a studio, where he could also welcome an increasingly large number of pupils. Through his relationship with Constantijn Huygens, and their continuing correspondence, Rembrandt's name became known at the court at The Hague. He was thus able to receive many aristocratic commissions, the fees for which were, however, not always settled promptly. Shrewdly, he avoided openly endorsing any particular religious persuasion; this enabled him to paint for Catholics, Mennonites, and Jews alike in the cosmopolitan atmosphere of Amsterdam.

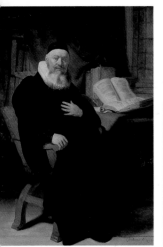

■ Rembrandt, *Pastor Johannes Elison*, 1634, Museum of Fine Arts, Boston. Rembrandt portrayed severe, clean-living pastors, interpreting their moral stance in a sober way.

■ Rembrandt, *Presumed Self-portrait as Standard Bearer*, 1636, Private Collection, Paris. The grandiloquent poses and showy clothes of Rembrandt's self-portraits of this period were in marked constrast to the portraits of black-clad Puritans. The happiest decade of Rembrandt's life and work is characterized above all by the sophisticated eclecticism of his models and style.

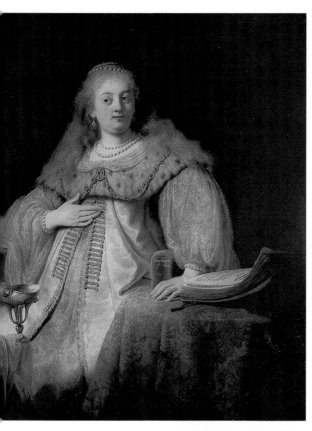

■ Rembrandt, *Artemisia or Sophonisba*, 1634, Museo Nacional del Prado, Madrid. The identity of the matronly heroine of this painting has not been identified with certainty. It may be Artemisia, wife of Mausolus, about to drink her husband's ashes mixed into a drink, or Sophonisba, Queen of Numidia, who chose to kill herself by drinking from a poisoned goblet rather than surrender to the Romans. Other suggestions have also been put forward. The model is undoubtedly Saskia.

■ Rembrandt, *Portrait of a Young Woman Holding a Fan*, 1633, Metropolitan Museum of Art, New York.

Rembrandt and women

There is no doubt that Rembrandt loved women. His all-consuming, deep love for Saskia was later replaced by stormier relationships, but his passion for women remained undimmed. Few other artists have succeeded in portraying women with the same intensity. His memorable interpretations of women's feelings and innermost secrets include portrayals of little girls, adolescents, young married women overcoming the embarrassment of coming out in society, mothers, pert servant girls, and failing old women who retained an inner wisdom.

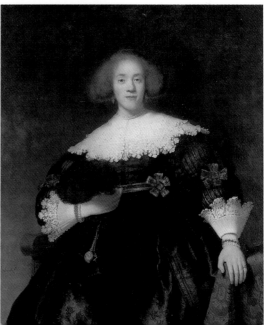

Self-portrait with Saskia

This delightful painting is housed in Dresden's Gemäldegalerie and dates from 1635. A portrayal of utter happiness, it cheerfully expresses Rembrandt's joy in his marriage. He holds Saskia on his knee and raises a glass to us.

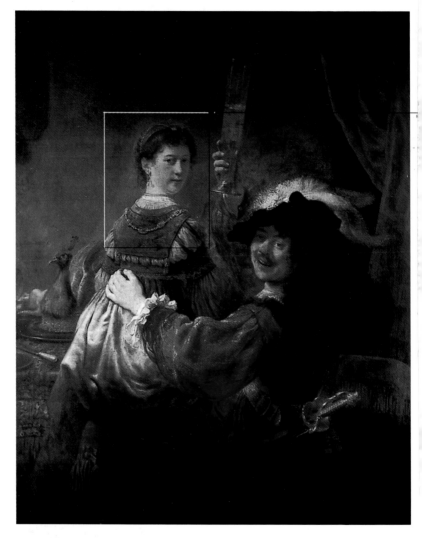

■ Saskia's expression betrays a certain embarrassment at the rather vulgar laughter of her husband. The scene has also been viewed as an interpretation of the parable of the prodigal son, who squandered his father's fortune on improper revelry. However, the genuine happiness expressed by the painting seems to contradict any possible intention to moralize.

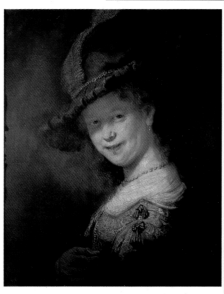

■ Rembrandt, *Saskia Smiling in a Plumed Hat*, 1635, Gemäldegalerie, Dresden. In the *Self-portrait with Saskia* shown opposite, Rembrandt's wife appears polite and controlled. Here, she seems more relaxed; the plumed hat was clearly part of the collection of theatrical props that the artist kept in his studio.

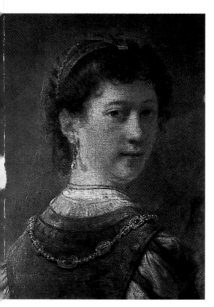

■ Rembrandt, *Self-portrait with Saskia*, 1636, engraving. A different, somber atmosphere is expressed here. Rembrandt and Saskia appear to reflect on the destiny of a family struggling to establish itself: the couple's first three children (one boy and two girls) failed to live beyond two months.

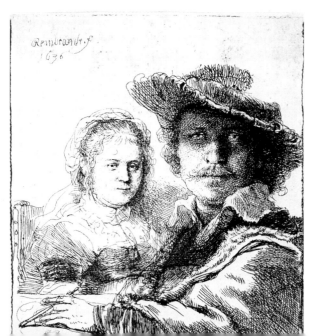

Foreign exoticism and Calvinist sobriety

■ Rembrandt, *Head of a Man in Oriental Costume*, 1635, Rijksmuseum, Amsterdam. This is most likely a character study rather than an actual portrait of the sitter.

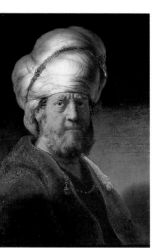

A love of anything new and extravagant, an inexhaustible curiosity, and the wish to possess whatever he painted are all characteristics that recur throughout Rembrandt's career. During his early years in Amsterdam, the artist experienced a daily onslaught of sights and sensations. An open, welcoming city, Amsterdam illustrates the two sides of 17th-century Holland: on the one hand, the pursuit of a sober, controlled family life that was mindful of proper behavior and respectful of the social hierarchy; on the other, an abundant cornucopia of all manner of goods that poured onto the quayside every day from foreign ports. During the 1630s, Dutch colonial expansion was at its height, with the consolidation of dominions in Brazil and the opening of emporia in various continents: Ceylon, Caracas, Pernambuco, Curaçao, Surinam, Java, the Moluccas, even faraway Tasmania. The Dutch fleet and army held their own against Spanish attempts to reconquer the country, but the true battles at this time were being fought elsewhere: Europe was ravaged by the Thirty Years War, and flourishing, wealthy Holland, which remained untouched by the conflict, came to be regarded as a kind of island of happiness.

■ Rembrandt, *Elephant*, British Museum, London. Rembrandt seized every opportunity to collect visual impressions. This drawing came about after a visit to the port at Amsterdam, where goods and natural curiosities from all over the world could be seen.

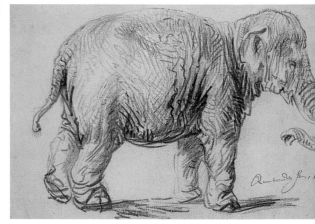

■ Rembrandt, *Portrait of Aechje Claesdr. Presser*, 1634, National Gallery, London. This old woman's expression and demeanour suggest moral and domestic virtues, and a parsimonious life.

■ Rembrandt, *Two Africans*, 1661, Mauritshuis, The Hague. Regarded as a preparatory sketch for a painting that was never executed, this shows Rembrandt's interest in different physical types. People from the Dutch overseas colonies were a common sight in Amsterdam.

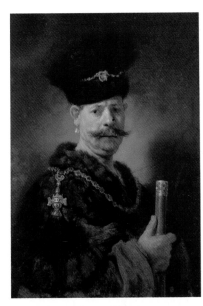

■ Rembrandt, *Portrait of a Man in Polish Costume*, 1637, National Gallery of Art, Washington, DC. Fur-trimmed clothing and hats came into fashion at this time, in imitation of Polish or Hungarian models.

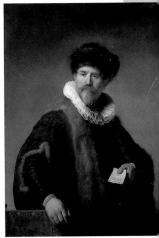

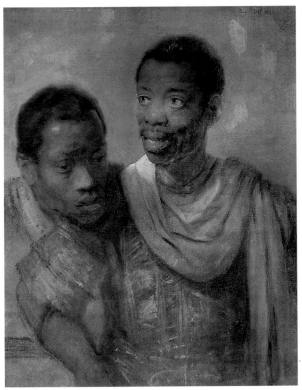

■ Rembrandt, *The Amsterdam Merchant Nicolaes Ruts*, 1631, The Frick Collection, New York. The pursuit of exoticism was important to Rembrandt as a necessary antithesis to the propriety of the Dutch Calvinists, whose dress deliberately reflected their morality and sobriety of attitude. Ruffs were the only permissible affectation.

The engravings

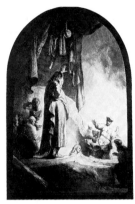

R embrandt is without question one of the greatest engravers of all time. His graphic output is impressive for the number and variety of its subjects, his consummate knowledge of the technique, and his expressiveness. Small genre sketches alternate with large, highly elaborate compositions, produced in various versions, each with slight variations. For Rembrandt, prints fulfilled a different function to painting, but remained first and foremost a formidable field of figurative research. He only seldom translated subjects he had already treated in his paintings into engravings. It was more usual for him to study totally new themes, innovatively developing the possibilities underlying the relationship between black and white, light and shade. The skill with which Rembrandt printed the plates, the exceptional control he exercised over the chemical solutions necessary to the process, and the knowledge that he could produce a considerable number of copies convinced him that engravings could help him in the teaching of his craft, especially in the workshop. Much of Rembrandt's earnings came from engravings, but would later prove insufficient to save him from financial ruin.

■ Rembrandt, *The Raising of Lazarus*, engraving. Rembrandt's pupils worked on this composition, no doubt stimulated by the open theatricality of the gestures, the unusual viewpoint (from Jesus' shoulders), and by the original treatment of light and shade. An example of these exercises is the painting by Carel Fabritius (see page 63).

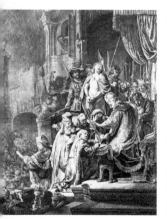

■ Rembrandt, *Ecce Homo*, 1636, etching. Here, Rembrandt has taken the engraving from a previous, monochrome painting (dated 1634), which is now in London's National Gallery.

■ Rembrandt, *The Hundred Guilder Print*, 1639–40, etching and dry-point. Even today, this magnificent composition continues to fetch high prices.

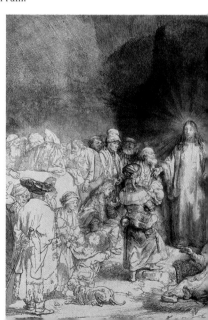

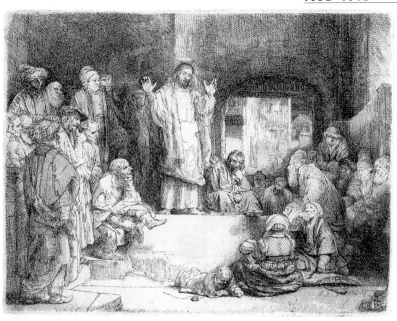

■ Rembrandt, *Jesus Preaching to the People* (*"Le petit tombeau"*), etching. This famous, frequently copied scene is powerful in its structure and luminosity.

■ Rembrandt, *St Jerome in an Italian Landscape*, etching and dry-point. In this work, Rembrandt reproduces a landscape he has never seen.

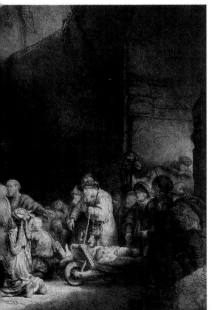

Italian and Flemish models

Constantijn Huygens, the first and most authoritative person to discover Rembrandt's talent, had early on noticed the particular affinity between the Leiden artist's work and the great classical artists, particularly the Italian masters and the school of Rubens at Antwerp. Rembrandt constitutes a spectacular exception in Baroque painting: he never undertook the obligatory journey to Rome and, indeed, hardly left his native Holland. Many reasons can be put forward for his decision: his profound indolence, the need to keep up an intensive working pace without "wasting time" on long journeys, the ready availability of important Italian works on the Amsterdam art market, and the widespread circulation of copies and engravings. Rembrandt was well-versed in Renaissance and Baroque art: his painting is far from self-contained or "spontaneous". On the contrary, he was constantly aware of the need to have his work endorsed at the highest level.

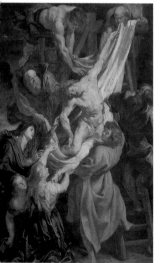

■ Pieter Paul Rubens, *The Descent from the Cross*, 1609–11, Courtauld Gallery, London. This oil sketch was for the great altarpiece in Antwerp Cathedral.

■ Rembrandt, *The Descent from the Cross*, 1632–33, Alte Pinakothek, Munich. Although he never went to Antwerp, Rembrandt was familiar with Rubens' altarpiece through works such as that shown far left, or through engravings or drawings. *The Descent from the Cross* is part of a group of religious paintings Rembrandt produced for the court at The Hague, a commission organized by Constantijn Huygens.

■ Above: This splendid and rare engraving of the *Madonna and Child* is an example of the care Rembrandt always took over figurative models. He used a print by Mantegna (below) as the basis for this extraordinarily luminous work, which he would certainly have had in his collection. The particularly intimate treatment of this theme is also found in the work of engravers from the previous century, such as the Italian Jacopo Francia (shown above right is a detail of a *Holy Family* by him) and the northern European Renaissance master Albrecht Dürer. The latter, a supremely gifted engraver, produced a number of versions of the *Madonna and Child*.





























MASTERPIECES

The Raising of the Cross

This is the first in a series of five paintings on Christ's Passion destined for the court of the House of Orange at The Hague. Work on the series, which is now in the Alte Pinakothek in Munich, began in about 1633.

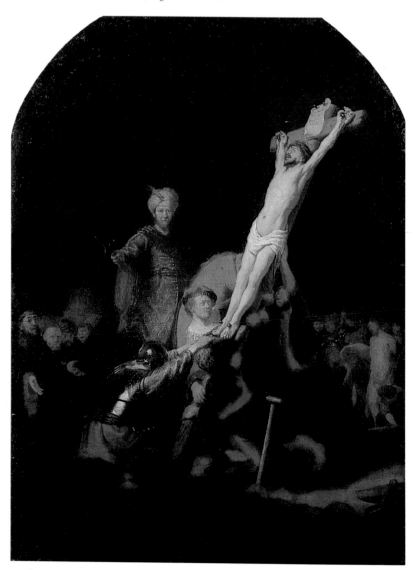

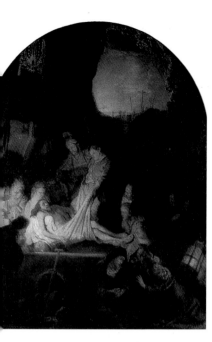

■ *The Entombment of Christ* was completed in 1639, together with the *Resurrection*. Progress on the Passion cycle for Prince Frederick Henry of Orange was overshadowed by the delay with which the artist's fees for the commission were paid and by aesthetic changes of heart by the House of Orange.

■ *The Resurrection of Christ* (1639) is extraordinarily inventive in its luminosity and composition. The Passion paintings all share the same format – 92 x 70 cm (36 x 27 in) – and a rounded outline at the top, in the style of a small altarpiece. The skilfully rendered chiaroscuro effects echo those in Rembrandt's engravings.

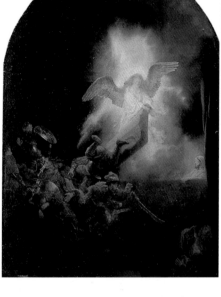

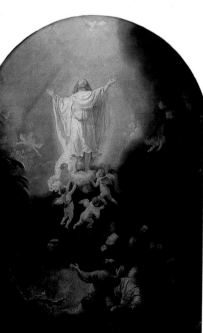

■ *The Resurrection of Christ*, dating from 1636, can be placed midway between *The Raising of the Cross* and *The Descent from the Cross* (c.1633) and the two paintings executed in 1639. During this time, Gerrit van Honthorst had become court painter at The Hague. Rembrandt later sold two further scenes: an *Adoration of the Shepherds* (now in London) and a *Circumcision*, which has been lost. The two paintings were purchased as finished works and were not commissioned.

BACKGROUND

Collectors, friends – and creditors

Rembrandt participated actively in Amsterdam's social life. In 1632 he was already regarded as a prominent figure, even receiving the visit of a legal official who had been sent to confirm the actual existence of a hundred well-known personages following a bet waged by two high-living citizens. Commissions by Huygens and the court, his contact with Dr Tulp (twice burgomaster of Amsterdam and a widely respected physician), his partnership with an established dealer such as van Uylenburch and, of course, his marriage to Saskia placed Rembrandt in a strong, enviable position. The portraits he executed during the 1630s, both painted and engraved, are a consummate record of Amsterdam's highest social circles. It is interesting to note his more indifferent portrayal of Catholics, Jews, Calvinists and Baptists, Mennonites, and members of some other congregations. Rembrandt had many friends and admirers but some of them would, within just a few years, turn into rapacious creditors. The artist went from success to ruin in just 15 years.

■ Rembrandt, *Portrait of Nicolaes van Bambeeck, Husband of Agatha Bas*, 1641, Musées Royaux des Beaux-Arts, Brussels. This portrait was one of a pair with a portrait of the sitter's wife, Agatha Bas (opposite). A comparison between the two works reveals their differing states of repair.

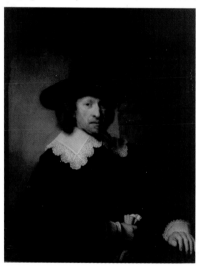

■ Frans Francken and David Teniers' *Interior of a Picture Gallery* (Courtauld Gallery, London) gives us an idea of a typical Flemish art collection of about 1640. Alongside religious paintings, there are a considerable number of "bourgeois" works, such as portraits and landscapes. The paintings are stacked, or propped on furniture.

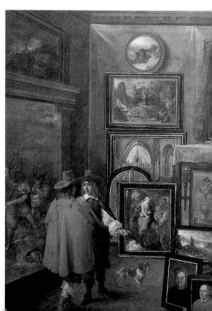

■ Reproduced opposite and left are two landscape engravings by Rembrandt: *Windmill in the Kemmerland* and the so-called *Six's Bridge*.

■ Rembrandt, *Jan Six*, 1647, etching. The original luminosity of this scene, with Rembrandt's friend Six reading casually by a window, was imitated many times by Dutch painters in the centuries that followed.

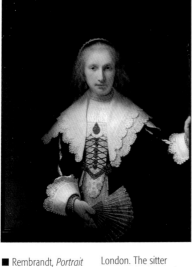

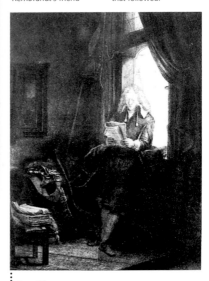

■ Rembrandt, *Portrait of Agatha Bas*, 1641, Royal Collection, Buckingham Palace, London. The sitter seems to look out of a window, in a skilful *trompe l'oeil* effect.

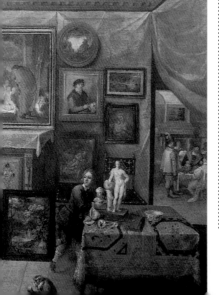

Jan Six

One of Rembrandt's closest friends, Jan Six occupied a special place in the artist's life. Wealthy and cultured, he wrote poetry and tragedies, had open political ambitions, shared Rembrandt's taste for collecting, and often helped him out financially. According to a highly credible anecdote, Rembrandt produced the drawing for *Six's Bridge* while enjoying a day out on his friend's estate – during a break over lunch while a servant went to fetch some mustard between courses.

MASTERPIECES

The Blinding of Samson

Now in the Städelsches Kunstinstitut, Frankfurt, this, Rembrandt's most violent work, dates from 1636. Rembrandt presented it to Constantijn Huygens in gratitude for the support he had received at court.

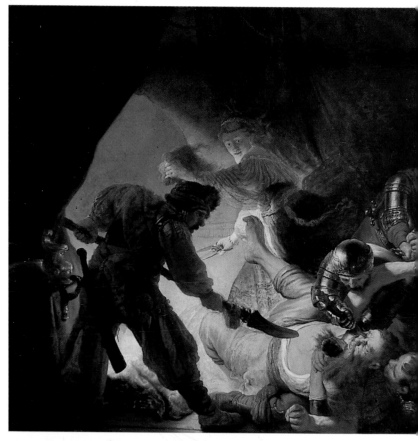

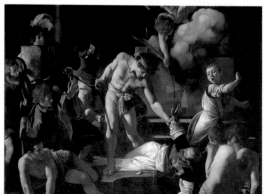

■ The dynamism and drama in the painting recall the work of Caravaggio, particularly *The Martyrdom of St Matthew* (1600–01) in the church of San Luigi dei Francesi in Rome.

■ Rembrandt, *Samson Betrayed by Delilah*, 1629–30, Staatliche Museen, Berlin. Rembrandt was clearly very interested in the story of Samson, returning to it several times in his career. This work, which captures the very moment of Samson's betrayal, is typical of Rembrandt's early period, while he was still working with Jan Lievens in his native Leiden.

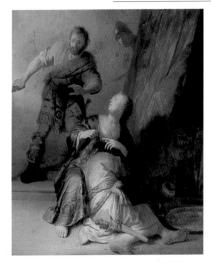

■ Rembrandt, *Samson Threatening his Father-in-Law*, c.1635, Staatliche Museen, Berlin. With his characteristic adherence to the biblical text, Rembrandt explores the story of Samson in all its detail, finding minor episodes among the Scriptures that are almost genre scenes. Here, the religious meaning is overshadowed by the characterization.

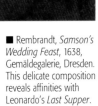

■ Rembrandt, *Samson's Wedding Feast*, 1638, Gemäldegalerie, Dresden. This delicate composition reveals affinities with Leonardo's *Last Supper*.

The workshop

Throughout his life, Rembrandt invested much energy in his role as workshop master. Even when he was very young, at the time of his partnership with Jan Lievens in Leiden, he would take in pupils and co-workers, who were often very talented. Not only did the students boost the work carried out in the workshop, but they also paid handsome fees for the privilege of studying with the master – although Rembrandt never exploited this, spending long hours tutoring his apprentices personally. During the 1630s, his workshop's quota of pupils was so high as to put Rembrandt's organizational skills very much to the test. The artist rented a large disused warehouse and set up his workshop there, dividing the space into autonomous little rooms for his students by means of partitions and drapes. His co-artists could thus work undisturbed (although the partitions were often ribaldly dismantled to reveal the presence of a nude model) and also take group lessons, in which they were invited to reproduce life compositions and make use of Rembrandt's collection of costumes and theatrical props.

■ Rembrandt, *Pupil Copying a Classical Statue*, engraving. This small, touching print portrays, almost stealthily, a young student who each evening studies the plaster cast of an ancient sculpture. The master's observation of the pupils' struggle to come to grips with the secrets of art is both amused and affectionate.

■ Rembrandt may have executed these two engravings (with a model seated in the half-shade and another with an oustretched leg) for teaching purposes. They are typical "academy" engravings, produced with a view to studying specific postures of the male nude. Such studies were mainly carried out to instruct pupils, who had the opportunity to observe and copy the master's own work with posed models in the studio – a useful exercise in developing their craft.

■ Constantijn van Renesse, *Annunciation*, Kupferstichkabinett, Berlin. This drawing, certainly executed in Rembrandt's workshop, presents a number of vigorous corrections made by the master, showing the care he took in reviewing his pupils' work.

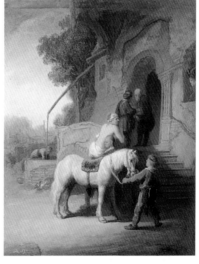

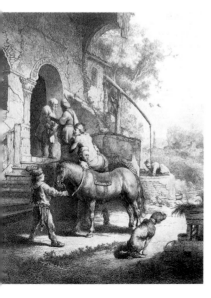

■ Rembrandt's relationship with his pupils is well illustrated by the *Good Samaritan* by Govaert Flinck (Wallace Collection, London, above), which is directly based on Rembrandt's engraving of the same subject (left). Flinck has omitted the embarrassing detail of the dog defecating in the foreground.

61

Theatre in Amsterdam

BACKGROUND

Recent studies on Rembrandt have unearthed interesting new information. Besides casting more precise light on the artist's output and more accurately separating original works from replicas and pupils' versions, they have also revealed aspects of the artist's cultural life that had been neglected until now. One of the most interesting conclusions drawn is that Rembrandt had a very strong love for the theatre, a passion he was able to indulge to the full in Amsterdam. Dutch 17th-century literature, which abounded in a variety of different publications, also included some notable dramatic texts. In spite of the more rigorous Calvinists viewing the excesses of the stage with suspicion, the theatre continued to thrive. Vondel, Holland's foremost 17th-century poet, was a prolific dramatist and even Rembrandt's friend, the collector Jan Six, penned a *Medea* in the classical manner. Cultured theatre alternated with travelling shows, particularly during festivals or markets: actors' poses, expressions, and costumes provided Rembrandt with a fascinating world from which he could draw inspiration.

■ Govaert Flinck, *Portrait of Rembrandt Dressed as a Shepherd*, c.1636, Rijksmuseum, Amsterdam. This is one of many examples of how Rembrandt enjoyed adopting different guises for portraiture.

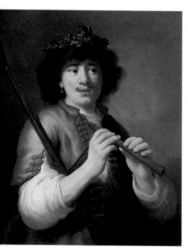

■ Rembrandt, *The Suicide of Lucretia*, 1664, National Gallery, Washington, DC. Here, the classical heroine strikes a distinctly theatrical pose. The first female actress appeared on the stage at Amsterdam in about 1640, creating something of a scandal.

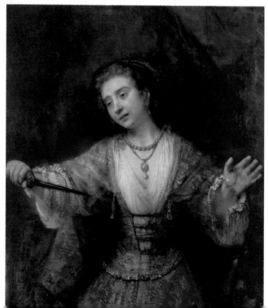

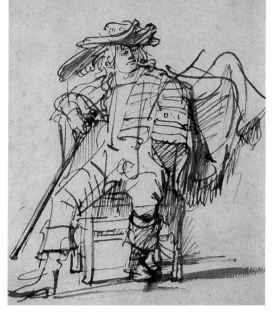

■ Rembrandt, *Seated Actor*, c.1635, Courtauld Gallery, London. Actors' excessive costumes and brash poses were a constant source of inspiration for Rembrandt, who is likely to have enjoyed Amsterdam's theatrical world and the many travelling shows performed in the city's theatres and streets.

■ Carel Fabritius, *The Raising of Lazarus*, c.1640, Muzeum Narodowe, Warsaw. Some of Rembrandt's own works, as well as those of his pupils, point to the performance of small but well-coordinated plays. Models and pupils would "pose" together, mimicking episodes from life or the Bible, which would then be copied by other pupils. This elegant painting is the work of one of Rembrandt's most gifted pupils, Carel Fabritius. Like his brother Barendt, Carel moved to Delft and was important in the artistic development of Jan Vermeer.

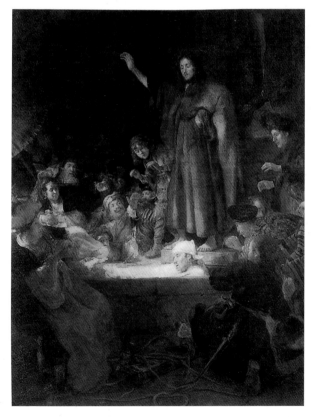

A house fit for a successful artist

During the first ten years Rembrandt spent in Amsterdam, he moved house frequently. From his lodgings in van Uylenburch's house he gradually progressed towards larger and more elegant dwellings. In January 1639, the artist spotted the house of his dreams, where he could settle his family and his rapidly growing collections of art and assorted objects. It was a stone and brickwork building dating from the beginning of the 17th century and located in a fairly central part of Amsterdam. Rembrandt paid the owners, Pieter Belten and Christoffel Thijssens, the handsome sum of 13,000 guilders. The artist was earning good money, and felt he could afford the house, even if the sum had to be paid in instalments. After lengthy negotiations, he took possession in May 1639, paying one-quarter of the purchase price as an advance and undertaking to pay the balance over the next five or six years.

■ Rembrandt's house in Sint Anthonisbreestrat, Amsterdam is now a museum housing some of the master's most important works. He and Saskia moved into the house in early May 1639; it was the most luxurious house the artist had ever lived in. The extremely high purchase price and running costs, however, were to bring about his financial ruin.

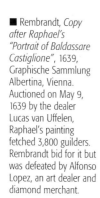

■ Rembrandt, *Copy after Raphael's "Portrait of Baldassare Castiglione"*, 1639, Graphische Sammlung Albertina, Vienna. Auctioned on May 9, 1639 by the dealer Lucas van Uffelen, Raphael's painting fetched 3,800 guilders. Rembrandt bid for it but was defeated by Alfonso Lopez, an art dealer and diamond merchant.

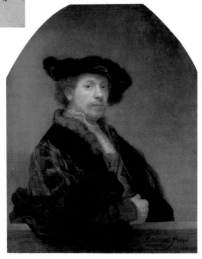

■ Rembrandt, *Self-portrait at the Age of 34*, 1640, National Gallery, London. The painting is directly inspired by Raphael's *Portrait of Baldassare Castiglione*. Evidently, having acquired the painting at auction by bidding against Rembrandt, Alfonso Lopez allowed him to study the work. The Dutch master's interpretation remains a memorable example of delicacy in its treatment of light and color.

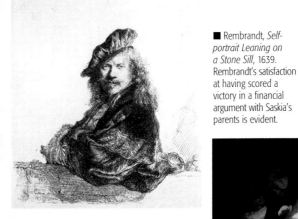

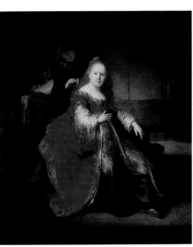

■ Rembrandt, *Self-portrait Leaning on a Stone Sill*, 1639. Rembrandt's satisfaction at having scored a victory in a financial argument with Saskia's parents is evident.

■ Rembrandt, *Esther Preparing to Intercede with Ahasuerus*, c.1633, National Gallery of Canada, Ottawa. Rembrandt owned the precious fabrics worn by his sitters in his works.

■ Michiel Sweerts, *A Painter's Studio*, Rijksmuseum, Amsterdam. In this work, Rembrandt's pupil seems to mirror the chaotic interior of the master's workshop, with many apprentices at work among casts of ancient statues, models posing, a variety of objects, and noble clients looking on. It seems impossible that anyone would have been able to concentrate in such an environment, but some of Rembrandt's greatest masterpieces were executed in a fascinating and confused atmosphere very similar to this.

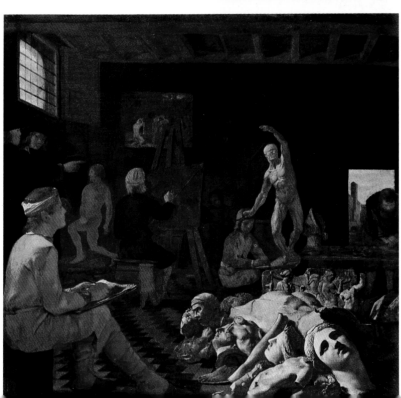

MASTERPIECES

The Mennonite Minister Cornelis Anslo

A member of the Mennonite minority, Cornelis Claeszoon Anslo was one of Holland's most famous preachers. This painting, dating from 1641 and now in the Gemäldegalerie (Staatliche Museen), Berlin, shows him with his wife.

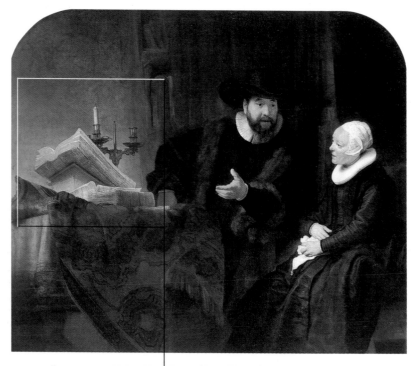

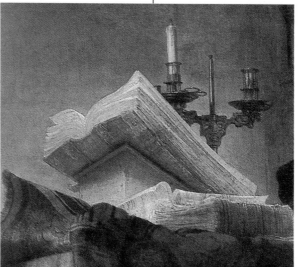

■ Positioned in the most luminous part of the composition, the book and candelabra assume a particular significance. All his life, Rembrandt continued to remember the power, light, and depth of the written word, in particular the Bible. Here, the symbolic meaning is emphasized by the relationship between books and candelabra – both sources of illumination.

■ Rembrandt, *Portrait of Cornelis Anslo*, 1640, drawing, British Museum, London. The contact between Rembrandt and Anslo began with this drawing. The preacher sits at his desk, with an open book on the book-stand and another large volume in his left hand.

The pose was retained for the engraved version; the face and dress remained essentially unchanged even in the painted version. However, the scene was expanded to take in his wife, which inspired Rembrandt to use the effective device of a dialogue between the couple.

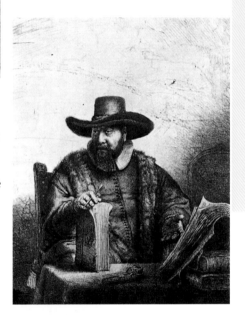

■ Rembrandt, *Portrait of Cornelis Anslo*, 1641, etching. This version represents the second stage in Rembrandt's progression towards the final oil painting. The artist seems to have risen to the challenge set by the poet Vondel: "Rembrandt should paint Cornelis' voice because his outward appearance is the least of the man; the invisible can only be intuited by hearing. Whoever wants to see Anslo, must listen to him". Rembrandt, indeed, only dwells briefly on the preacher's features; the gesture that accompanies what Anslo is saying, the visibly moved expression of the woman, and the ineffable light of knowledge that illuminates the entire scene are totally in keeping with Vondel's expectations, and breathe life into one of the most intense "voice portraits" to be found in the entire history of painting.

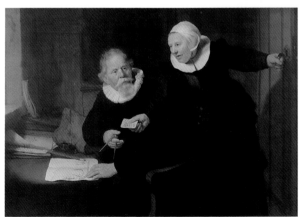

■ Rembrandt, *The Shipbuilder and his Wife*, 1633, Royal Collection, Buckingham Palace, London. As we can see from other masterpieces, such as *The Happy Couple* and *The Jewish Bride*, Rembrandt painted several scenes of conjugal intimacy. Here, the severe engineer appears to be irritated by his wife's interruption.

The guilds

■ Right: Nicolaes Pickenoy, *The Guard of Captain Jan Vlooswijck*, 1642, Rijksmuseum, Amsterdam. Works such as this serve to highlight the exceptional novelty of Rembrandt's paintings.

■ Willem Kalf, *Still Life with the Drinking Horn of the Guild of the St Sebastian Archer's Guild*, c.1653, National Gallery, London. This lavish still life gives us an idea of the pomp that characterized the gatherings of the Dutch guilds, described in contemporary chronicles as glamorous gastronomic exploits. In the background is the symbolic horn used for libations and toasts. This magnificent 16th-century artefact is housed in Amsterdam to this day.

The history of Holland in the 17th century, the proud vindication of the United Provinces' independence, and the way in which the cities had successfully protected themselves against danger (fire, flood, crime, vagrancy): all were factors in arousing a keen sense of national and civic solidarity in the Dutch population. This was expressed through all kinds of guilds – associations of merchants or artisans formed for the mutual aid and protection of their members. Parades, commemorative ceremonies, and banquets hosted by the main guilds abounded. Like anywhere else, however, Holland was no stranger to excess, and the strictest Calvinist preachers constantly thundered against ostentation and profligacy. Without a proper, blood aristocracy, the more elevated Dutch circles established their superior position in society through their involvement with the highest professional bodies. Leading or presiding over such an organization was a recognition of prestige, and this status was often demonstrated by the commissioning of works of art and group portraits to decorate the headquarters. Rembrandt had many professional contacts with guilds, corporations, and civic bodies, which led to some of his finest masterpieces, such as the two *Anatomy Lesson* paintings, commissioned by the Guild of Surgeons, the group portrait of the Clothmakers' Guild, known as *The Syndics*, and, of course, *The Night Watch*.

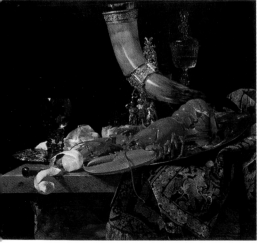

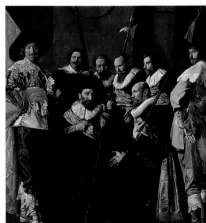

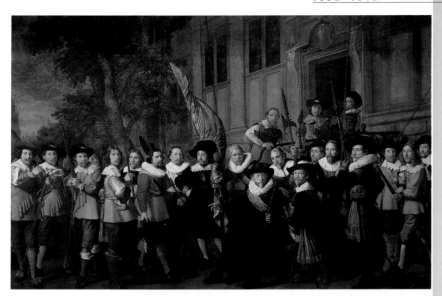

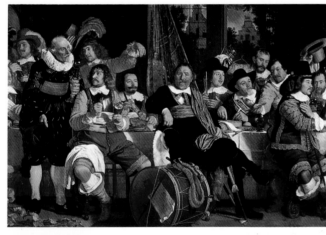

■ Right: Bartholomeus van der Helst, *Banquet of the Civic Guard*, 1648, Rijksmuseum, Amsterdam. The guilds' convivial social gatherings culminated in feasts, at which legendary quantities of fine and expensive foods were consumed. Van der Helst engagingly portrays the members of the Civic Guard at table, gathered to celebrate the Peace of Westphalia.

■ Frans Hals and Pieter Codde, *The Company of Captain Reynier Reael*, 1636, Rijksmuseum, Amsterdam. Predating Rembrandt's *Night Watch* by just a few years, this large-scale painting represents the peak of official, "posed" group portraiture. Unlike Rembrandt's masterpiece, the figures here, rather stilted and self-conscious, are clearly aware of having to adopt poses and expressions that befit their status. Frans Hals' fresh brushstrokes and lively style, however, prevent any risk of monotony or repetitiveness from seeping into the work.

Preparing for a masterpiece

Ten years after *The Anatomy Lesson of Dr Tulp*, Rembrandt began work on another group portrait: the militia company of Captain Frans Banning Cocq, the masterpiece better known by the erroneous name of *The Night Watch*. This was an extremely prestigious commission, intended to be the unquestionable apex of the master's career. In tackling this enormous painting, Rembrandt revised and re-assessed every single stage in his artistic training and in the earlier part of his output: the unsurpassed liveliness of his portraits, richly elaborate compositions, and a depth of color reminiscent of Venetian Renaissance painting. *The Night Watch* is nothing less than the perfect synthesis of Rembrandt's stylistic choices. As with *The Anatomy Lesson of Dr Tulp*, it provides a wholly original but coherent interpretation within the context of a clearly defined, typically local tradition. Perfectly integrated into Dutch customs and culture, of which he was a conscious and satisfied exponent, Rembrandt was nevertheless able to draw on foreign models when appropriate, without any reverential timidity in tone or dimension.

■ Jakob Backer, *The Company of Captain Cornelis de Graeff*, 1642, Rijksmuseum, Amsterdam. Executed in the same year as *The Night Watch*, and similar in subject-matter, this work remains faithful to the descriptive tradition.

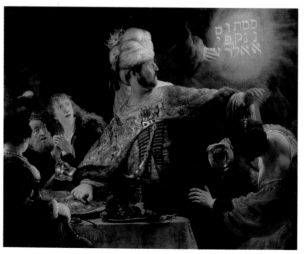

■ Rembrandt, *Belshazzar's Feast*, c.1635, National Gallery, London. At the age of about 30, Rembrandt displayed a keen interest in strongly dramatic scenes, with great figures involved in emotional situations. The Hebrew script on the wall, reads: "God hath numbered thy kingdom, and finished it".

■ Rembrandt, *Portrait of Menasseh-ben-Israel*, 1636, etching.

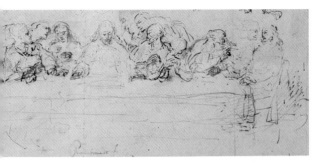

■ Rembrandt, *The Last Supper, after Leonardo da Vinci*, c.1635, Kupferstichkabinett, Berlin. Leonardo's supreme model was crucial in Rembrandt's exploration and understanding of the group portrait.

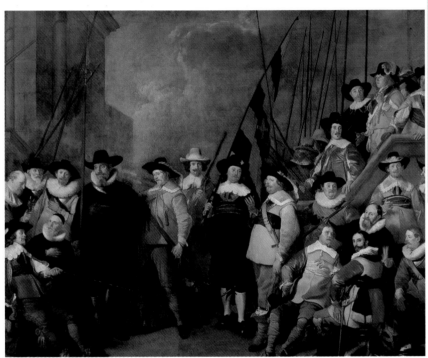

Mene mene tekel: a linguistic enigma

Like Titian, whose heir he regarded himself, Rembrandt displayed a keen sense of curiosity and a tireless desire for knowledge and understanding. This led him occasionally to come across insoluble problems. A typical example is the feast of Belshazzar, who, in the middle of the banquet, sees a mysterious hand writing an illegible prophecy on the wall. To understand why Belshazzar was unable to read the divine script, Rembrandt turned to Menasseh-ben-Israel, a Jewish man of culture, who solved the arcane mystery by explaining that the characters were intended to be read vertically and not horizontally.

71

The Night Watch

Executed in 1642 and now in the Rijksmuseum, Amsterdam, this is Rembrandt's largest and most famous painting and one of the most important works in 17th-century European art. The title by which it is commonly known in no way reflects the scene depicted, which actually takes place in daylight. This is a portrait of the civic militia of Captain Banning Cocq. Destined for the seat of the Civic Guard in Amsterdam, the work was paid for by 16 of the sitters, in varying amounts according to their position.

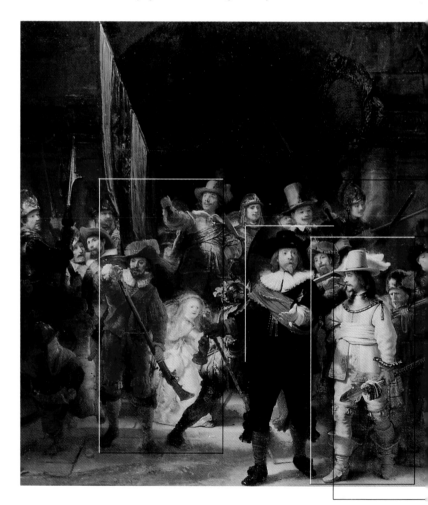

■ The group of figures, all shown in motion, includes 28 adults and three youths. The presence of a fair-haired little girl, wearing a light dress with a chicken strapped to her belt, has given rise to debate. The child, who looks frightened, occupies an almost central position, to the left of Captain Cocq and below the standard bearer.

■ Contrasting with the severe, authoritative expression of the captain is the fancily dressed and rather frivolous-looking Lieutenant Willem van Ruytenburgh, the most luminous figure in the entire painting.

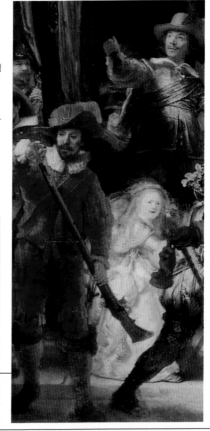

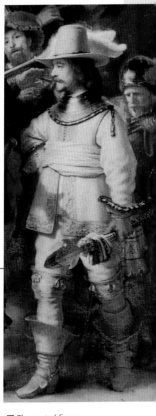

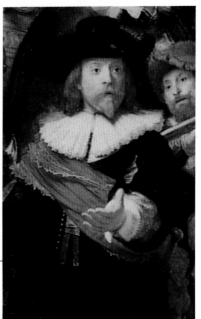

■ The central figure in the action is Captain Frans Banning Cocq, shown in the act of preparing the men for a parade. Defying the traditional convention of static portraits, Rembrandt opts for a moment of action and dynamism.

73

1642–1657

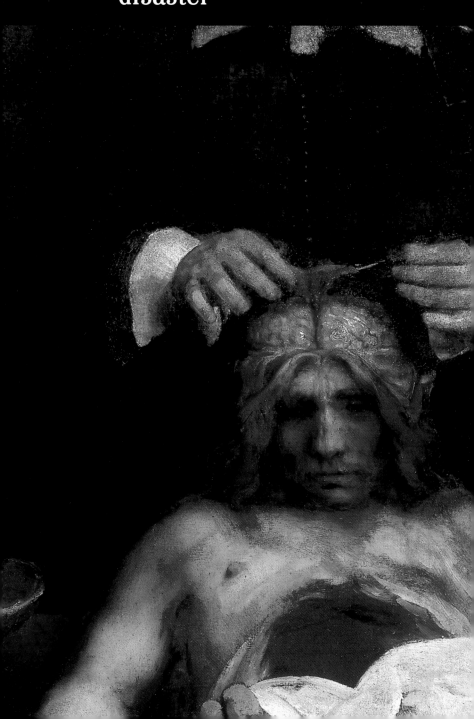

Hurtling towards disaster

The death of Saskia

Rembrandt's life has provided many opportunities for novels and film interpretations: the most central events – and the key to understanding the master – are those that took place in 1642. Rembrandt was at the peak of his fame and economic success thanks to a number of factors: the favourable reception of *The Night Watch* and *The Hundred Guilder Print;* the support of his many pupils; the growing requests for works of art; and the praise of art writers. Parallel to all this success, however, came a series of bereavements: having already buried both his parents, Saskia's cherished sister, and three of his children who died in infancy, Rembrandt now faced the gravest loss of all – Saskia. After giving birth to Titus (who was baptized in September 1641), the physical strain of childbirth was compounded by tuberculosis and she was unable to recover. Aged just 30, Saskia died on June 14, 1642. After a provisional burial, she was laid to rest on July 9 in the left-hand transept of the Oudekerk.

■ Rembrandt, *The Farewell of David and Jonathan*, 1642, State Hermitage Museum, St Petersburg. This biblical painting clearly reflects the personal vicissitudes undergone by the artist himself: the embrace between David and Jonathan becomes a moving farewell between Rembrandt and Saskia.

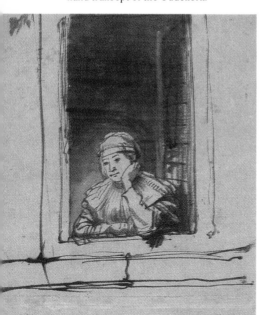

■ A memory of happier years: Saskia leans out of a window in a watercolor drawing by Rembrandt, now in the Museum Boymans van Beuningen in Rotterdam. The many pictures Rembrandt has left us of Saskia are a kind of private diary charting the course of their marriage, which was clearly rich in intensity and feeling.

■ Rembrandt, *Saskia as Flora*, 1641, Gemäldegalerie, Dresden. In this last portrait of the dying Saskia, there are circles under her eyes, she is visibly frail, and her hair is dry and faded. Rembrandt does not forget her gentle smile, however, and gives her the tender gift of a single red flower. The contrast between this moving portrait and the flourishing pictures of Saskia as Flora in earlier years, in which she is shown surrounded by a multitude of flowers, is striking. It captures the awareness of imminent death and expresses an eternally enduring declaration of love.

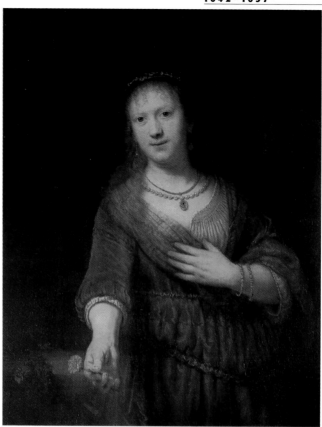

■ Rembrandt, *Death Appearing to a Wedded Couple*, 1639, etching.

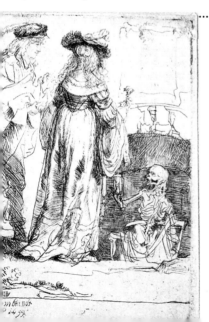

Testament and burial

On June 5, 1642, nine days before her death, Saskia made her last will and testament. She left half of her dowry of 40,000 guilders (we do not know if the money was still available, because Rembrandt was exempted from having to draw up an inventory) to her husband and half to Titus, with the clause that the money should not be administered by the Chamber of Orphans, but by Rembrandt himself. Twenty years after Saskia's death, the artist was forced to sell the tomb in the prestigious Oudekerk, and to have her ashes moved to the Westerkerk.

Women in Dutch society

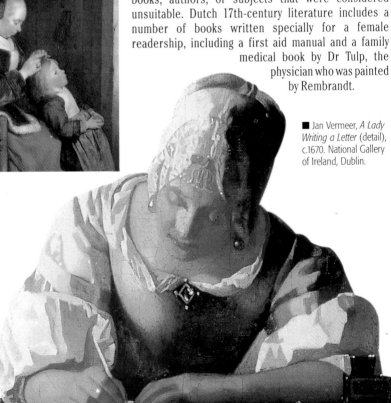

■ Gerard Ter Borch, *Looking for Head Lice*, 1653, Mauritshuis, Amsterdam. The principal role played by women in the Dutch family was to maintain order, keep a clean house, and look after the children.

Saskia's death was not just a personal tragedy for Rembrandt but also the start of a series of difficulties in the organization of his family life. Women played a key role in Dutch society, one that was essentially moral and organizational as opposed to the more "financial" role undertaken by the men. Women managed the home, cared for the children (both for the sake of the family and for the nation as a whole, as a number of widely circulated pamphlets on hygiene and housewifery admonished), and, with the assistance of a servant girl, were responsible for keeping the house impeccably clean. A medium level of schooling ensured that Dutch ladies were moderately cultured, although they were discouraged from knowing about books, authors, or subjects that were considered unsuitable. Dutch 17th-century literature includes a number of books written specially for a female readership, including a first aid manual and a family medical book by Dr Tulp, the physician who was painted by Rembrandt.

■ Jan Vermeer, *A Lady Writing a Letter* (detail), c.1670. National Gallery of Ireland, Dublin.

■ Pieter de Hooch, *The Larder*, 1658, Rijksmuseum, Amsterdam. In the Calvinist society, the mother's duty within the family was above all to teach her children how to keep house properly. Many of De Hooch's paintings show mothers instructing their daughters in matters of housewifery.

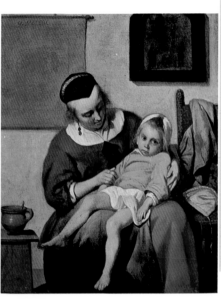

■ Jan Miense Molenaer, *The Harpsichord Player*, 1635, Rijksmuseum, Amsterdam. The woman portrayed in this picture may be Judith Leyster, Molenaer's wife and a gifted painter in her own right. Leyster is an example of a an emancipated female artist, fully aware of her role in society.

■ Gabriel Metsu, *The Sick Child*, c.1660, Rijksmuseum, Amsterdam. Dutch women were renowned throughout Europe for the affectionate way in which they cared for their children. Hugs, kisses, and the attention lavished on children were repeatedly remarked on by travellers and chroniclers.

Women and art: the case of Judith Leyster

A female artist of considerable talent features in the history of Dutch 17th-century art: Judith Leyster, a near-contemporary of Rembrandt's, is not as well known as she ought to be because, to this day, many of her paintings continue to be attributed to her first teacher, Frans Hals. Born in Haarlem in 1609, Leyster learned her craft in the workshop of the great portrait painter and fellow townsman Hals. Towards 1629, she moved to Utrecht. Her style is characterized by bold, quick brushstrokes and is rich in dense, Caravaggesque touches. After her marriage to her colleague Molenaer, Judith Leyster followed his example and took up genre painting.

A Woman in Bed

Dating from 1645 and now in the National Gallery of Scotland, Edinburgh, this painting shows a girl drawing back the drapes of her bed. It may be a biblical subject, possibly Sarah waiting for Tobias on her wedding night.

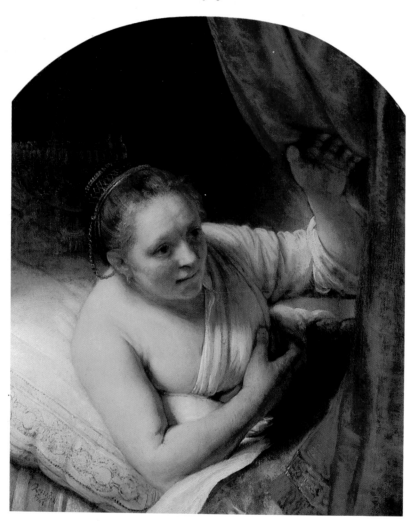

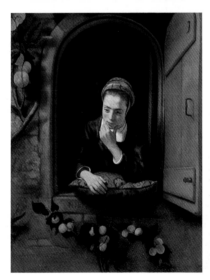

■ Rembrandt, *A Girl Leaning on a Stone Pedestal*, 1645, Dulwich Picture Gallery. Much later, works such as this were greatly admired by the Impressionists.

■ Samuel van Hoogstraten, *Young Girl Behind a Door*, The Art Institute, Chicago. Here, Rembrandt's pupil borrows elements of his teacher's style.

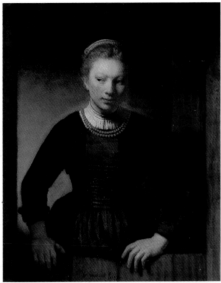

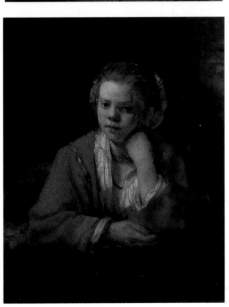

■ Nicolaes Maes, *Young Girl at a Window*, c.1655, Amsterdam, Rijksmuseum. For a long time wrongly attributed to Rembrandt, this is in fact the work of one of his most sensitive and original pupils.

■ Rembrandt, *Young Girl at a Window*, 1651, Statens Konstmuseer, Stockholm. In his private works, Rembrandt began to experiment with the long, separate brushstrokes that would characterize the style of his later paintings.

Titus and Geertje

Left with the nine-month-old Titus when Saskia died, Rembrandt employed Geertje Dircz as nurse and housekeeper. A widowed farmer's wife from Zeeland, she carried out her duties with energetic efficiency. Illiterate but sensible, rugged, and healthy, she was the very antithesis of Saskia. Before long, she had become the artist's mistress. Rembrandt's affections were now shared between tenderness towards his infant son and a private liaison that, more than reprehensible, was decidedly scandalous within the upright context of official Calvinist society. Rembrandt was not involved with the religious community and spent more than he earned, often on extravagant purchases. He kept exotic animals as pets (including an almost inconceivably filthy monkey that was grossly out of place in a clean Dutch home) and was conducting a blatant affair with his child's nurse. All of these things compromised his fame in his own country, although foreign art writers and collectors still took an interest in his work. His family life had meanwhile found a certain stability, but his relationship with Geertje was soon destined to turn sour.

■ Rembrandt, *A Woman in Dutch National Costume*, c.1638, British Museum, London. Titus' nurse was a rough country-woman from the northern Zeeland region.

■ Rembrandt, *Woman at a Window*, 1656–57, Staatliche Museen, Berlin. After Saskia's death, Rembrandt's love life became complicated. While Geertje was still mistress of the house, he began a liaison with Hendrickije Stoffels. She posed as model for this painting, which echoes a work by Palma the Elder.

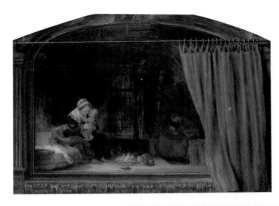

■ Rembrandt, *The Holy Family with a Cat*, 1646, Staatliche Museen, Gemäldegalerie, Kassel. The *trompe l'oeil* of the parted curtain, in front of the figures, is cleverly executed.

■ Rembrandt, *Titus at his Desk*, 1655, Museum Boymans van Beuningen, Rotterdam.

■ Rembrandt, *Geertje Dircx (?)*, Teylers Museum, Haarlem. This painting may show Geertje seen from behind, with the young Titus barely sketched in at the side.

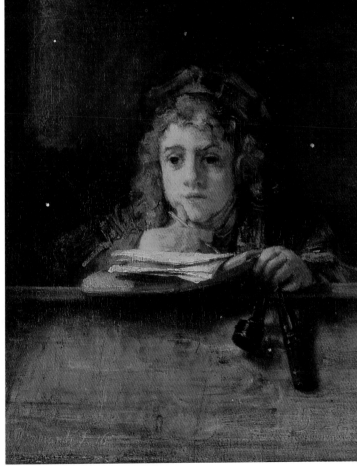

The Holy Family with Angels

Painted in 1645 and now in the State Hermitage Museum, St Petersburg, this affectionate painting is part of a large number of works devoted to the birth and early childhood of Jesus – no doubt related to Titus' early years.

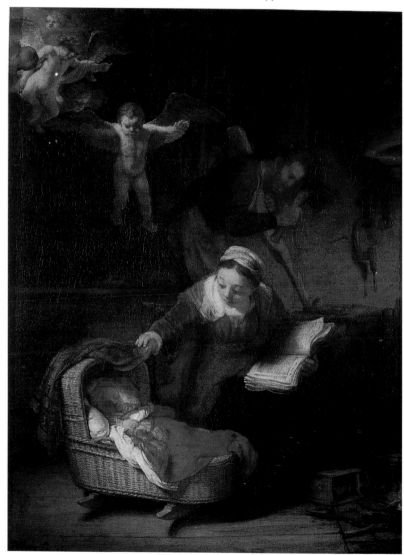

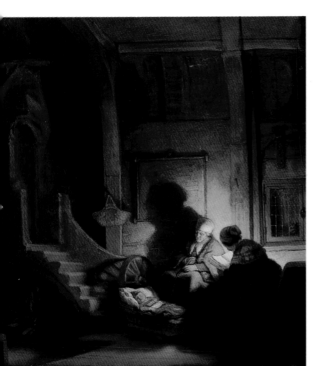

■ Rembrandt, *the Holy Family at Night*, c.1645, Rijksmuseum, Amsterdam. The fragile concept provided by traditional religious iconography is discarded in favor of a scene of immediate, moving realism. The deep evening shadows, the frail light emanating from the child asleep in his crib, and the reflection on the "three ages of man" suggested by the presence of the mother and grandmother combine to make this one of Rembrandt's most touching works.

■ Rembrandt, *The Woman Taken in Adultery*, 1644, National Gallery, London. This work represents a return to the "fine painting" of Rembrandt's early years.

■ Rembrandt, *The Adoration of the Shepherds*, 1645, Alte Pinakothek, Munich. Even if we can trace elements of previous works in this painting, this is still a powerful picture. It is part of a group of canvases devoted to biblical subjects, not executed to a commission but marketed independently.

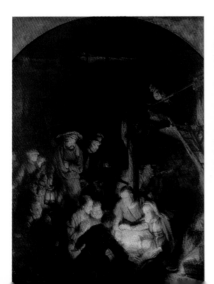

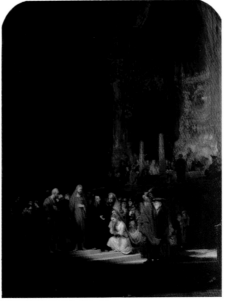

A new social order

■ Rembrandt, *The Unity of the Country*, c.1640, Museum Boymans van Beuningen, Rotterdam. This monochrome painting can be interpreted as a complex allegory on the need for union and concord among the United Provinces, in the wake of the dramatic and bewildering events of the Thirty Years' War. In terms of technique, it is a remarkable example of a deliberately "unfinished" work, with some parts merely sketched in.

The memorable Battle of the Downs in 1639 banished once and for all the threat of a Spanish reconquest of the Dutch territory. The United Provinces were, however, continually obliged to look for new allegiances among other European powers. At home, the political situation was relatively stable (only Leiden, Rembrandt's native city, displayed occasional instances of social hardship) and the Dutch people were unanimously united in upholding a few basic values: the tolerance of foreign communities and different religions, a strongly nationalistic feeling, the perfect organization of all social strata: family, neighborhood, city, state. This led to an intolerance of people who dropped out of society – tramps, gypsies, and people of no fixed abode – and promoted the constant pursuit of new guilds and business partnerships. A new generation of merchants and financiers gradually came to run the Dutch economy and, by extension, to dominate the collecting of works of art. The seat of government was at the Hague, with the *stadhouder* based in a luxurious court. The republic was changing, almost unconsciously, into the stable monarchy of the House of Orange.

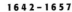

■ Govaert Flinck, *The Company of Captain Albert Bas*, 1645, Rijksmuseum, Amsterdam. After *The Night Watch*, civic guard companies requested livelier and more dynamic group portraits than had been the norm in the past. The taste for this particular type of collective picture persisted for a long time in Holland.

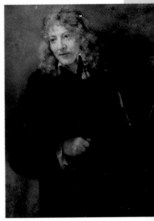

■ Rembrandt, *Portrait of Nicolaes Bruyningh*, 1652, Staatliche Museen, Gemäldegalerie, Kassel. The subject typifies the new, dashing type of Dutch gentleman.

■ Gerrit Berckheyde, *View of the Binnenhof at The Hague*, Mauritshuis, The Hague. This impressive, originally medieval building, which faces a romantic little lake, housed the Orange court and remains the seat of the Dutch government to this day.

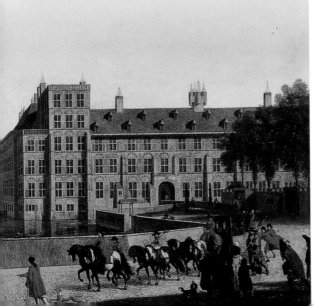

A clash with the law: friends turn away

One of the clauses in Saskia's will stipulated that Rembrandt must not remarry or he would forfeit half his inheritance. The artist now lived through a very difficult period in his life. Patrons' tastes were changing and the morally upright Calvinists condemned his personal life as seriously improper. Rembrandt lived openly with Geertje, spent large sums of money on bizarre collector's items, and practiced no religion. Gradually, friends disowned him and some pupils left his studio. Only Jan Six remained constant in his support and also helped the artist out financially. On January 24, 1648, Geertje made her own will and testament, naming Titus as her sole heir. The jewels that had belonged to Saskia were to be part of the inheritance. A few months after this, when the relationship between Rembrandt and Hendrickije Stoffels had become evident, Geertje sued the artist for breach of promise, accusing him of reneging on a proposal of marriage. The tribunal found in favor of Rembrandt, but stipulated that he should pay a considerable annual pension to Geertje. In 1649, the master countersued Geertje for pawning Saskia's jewellery. The lengthy lawsuit ended on October 23, 1649; Geertje was detained in the women's house of correction in Gouda, but Rembrandt still had to keep up the annual pension payment of 200 guilders.

■ Rembrandt, *Homer Reciting his Verses*, 1652, Six Collection, Amsterdam. During his years of financial hardship, Rembrandt repeatedly turned to the classical literature for inspiration, particularly to Homer. The blind bard appears in many of Rembrandt's works dating from the 1650s.

■ Rembrandt, *A Woman Sleeping (Hendrickije Stoffels)*, 1655–56, British Museum, London.

■ Rembrandt, *Hendrickije Stoffels*, c.1652, Musée du Louvre, Paris. Stoffels acted as a witness for the artist in the suit brought against him by Geertje.

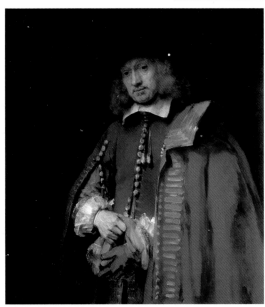

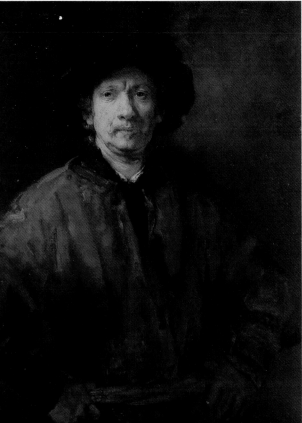

■ Rembrandt, *Portrait of Jan Six*, 1654, Six Collection, Amsterdam. This is one of Rembrandt's most important portraits. Six (who was also the author of the first catalogue of Rembrandt's etchings) adopts an impatient pose, pulling on his gloves. As this was a portrait destined for a friend, Rembrandt was able to apply the color loosely, with large brushstrokes, in a manner similar to Titian's late style. The painting has always remained in the Six family collection.

■ Rembrandt, *Self-portrait*, 1652, Kunsthistorisches Museum, Vienna. Here, the artist presents himself as a craftsman.

LIFE AND WORKS

A masterpiece lost and found: Danaë

Every museum in the world wants to acquire works by Rembrandt, but detailed research carried out by the Rembrandt Research Project has led to a general reassessment of attributions, which may have been too hastily determined in earlier years. A group of extremely important works (excluding, of course, the masterpieces housed in Amsterdam's Rijksmuseum) is to be found in the State Hermitage Museum in St Petersburg. Many beautiful works that are crucial to an understanding of Rembrandt's painting, especially his mature and late period, found their way to the former capital of Tsarist Russia, founded by Peter the Great, a champion of Dutch painting and culture. Among the most prized works, *Danaë* has had a singular history. Repeatedly revised by the master, the splendid mythological figure inspired by Titian was badly damaged by a vandal, who hurled corrosive acid at the canvas. The painting was withdrawn for many years, and regarded as a lost masterpiece. It was exhibited in public again in the spring of 1998, after lengthy and successful restoration work.

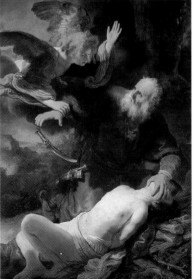

■ Rembrandt, *The Abduction of Ganymede*, 1635, Gemäldegalerie, Dresden. Ganymede, wetting himself in fear, is engagingly drawn.

■ Rembrandt, *Danaë*, 1636–54, State Hermitage Museum, St Petersburg. Rembrandt touched up this work several times over the course of 18 years.

■ Rembrandt, *The Angel Stopping Abraham from Sacrificing Isaac to God*, 1635, State Hermitage Museum, St Petersburg.

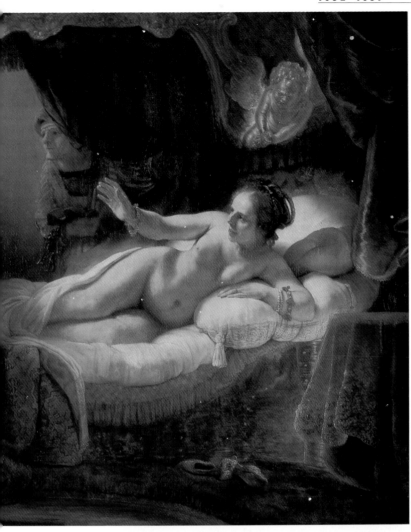

■ Rembrandt, *Diana Bathing*, 1634, Wasserburg Anholt Museum, Anholt. This work, classical in feel, was most likely suggested by Constantijn Huygens, who encouraged Rembrandt to devote himself to the classical themes of mythology and ancient literature.

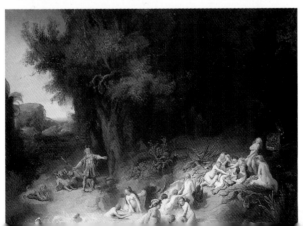

A Woman Bathing in a Stream

Regarded by some as a portrait of Hendrickije Stoffels, this painting, which used to be regarded erroneously as unfinished, dates from 1654 and is in the National Gallery, London.

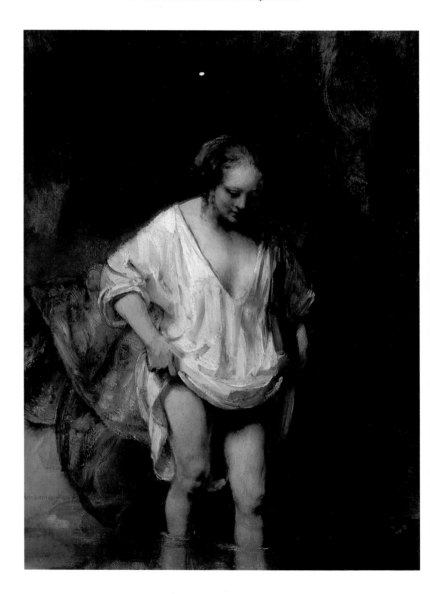

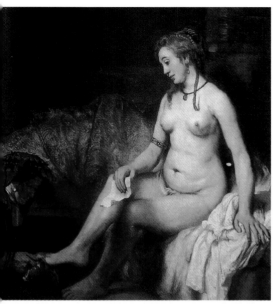

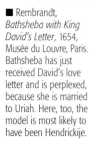

■ Rembrandt,
*Bathsheba with King
David's Letter*, 1654,
Musée du Louvre, Paris.
Bathsheba has just
received David's love
letter and is perplexed,
because she is married
to Uriah. Here, too, the
model is most likely to
have been Hendrickije.

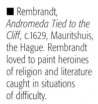

■ Rembrandt,
*Andromeda Tied to the
Cliff*, c.1629, Mauritshuis,
the Hague. Rembrandt
loved to paint heroines
of religion and literature
caught in situations
of difficulty.

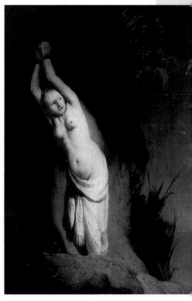

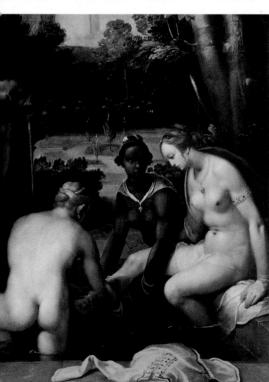

■ Cornelis van Haarlem,
Bathsheba, 1594,
Rijksmuseum, Amsterdam.
A fine example of late
Mannerism, this painting
was certainly an important
compositional source for
Rembrandt's *Bathsheba*.

93

Changing tastes

In 1648, the Peace of Westphalia put an end to the bloody Thirty Years' War and new political scenarios meant a redrawing of the map of Europe. The threat to Holland now came from the sea: from 1651, Dutch admirals engaged in a series of naval battles with the English. At stake was control over the commercial routes in the North Sea. After a few serious defeats, the Dutch were forced to review their colonial policies; they abandoned settlements in Brazil and concentrated on landing-places on routes to the Orient, founding Cape Town in 1652. The 1650s also saw a change in taste on the part of Dutch collectors and the general public. They purchased sumptuous paintings, luxuriant still lifes, elaborate landscapes, and works that were more courtly in tone than the descriptive, popular works that had prevailed in previous decades. The new generation, born after the hard-fought, glorious war of independence against Spain,

■ Below: Jan van der Heyden, *The Martelaarsgracht in Amsterdam*, Rijksmuseum, Amsterdam. Unlike Pieter Saenredam's severe views, van der Heyden's urban landscapes were immensely successful.

did not share the excessive rigour of their elders, tending to favor a more exuberant, decorative style and painting that could convey the feeling of wealth acquired.

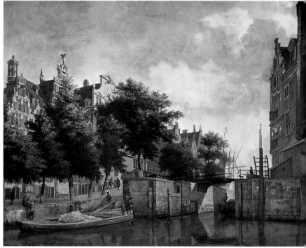

■ This still life by Willem Kalf (Thyssen-Bornemisza Collection, Madrid) features luxury objects such as a Chinese porcelain bowl.

■ Jan Steen, *The Feast of St Nicholas,* Rijksmuseum, Amsterdam. Jan Steen provides us with the most intimate, amusing scenes of Dutch private life. Here, a group of children enjoy their Christmas gifts. The little girl is overjoyed with her doll, while the rascal next to her, who has received nothing, whines.

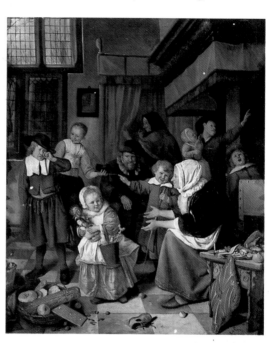

■ The most significant novelty in the Dutch artistic taste of the mid-17th century was the demand for lavish still lifes, triumphs of luxury, such as this one by Abraham van Beyeren in the Rijksmuseum.

■ Gérard de Lairesse, *The Emperor Augustus Patronizing the Arts,* 1667, Muzeum Narodowe, Warsaw. The paintings by De Lairesse, formerly a pupil and an imitator of Rembrandt's reflect the new, classical taste of collectors in the Netherlands in their titles and themes. A comparison with works by Rembrandt dating from the same period reveals marked similarities.

95

Rembrandt's genre paintings: still life and landscape

From his earliest years, Rembrandt clearly favored historical painting as a genre and produced works based on biblical, mythological, or literary stories, which may be compared with the Italian Renaissance tradition. Although he was an excellent portrait painter, and portraits progressively became the most profitable part of his painterly activity, he preferred the "great" subjects. Paintings by him that may be included in the development of the so-called genre painting popular with Flemish and Dutch collectors, therefore, are very rare. There are, however, about a dozen pure landscape paintings (generally not regarded as being among the artist's most impressive masterpieces) by Rembrandt, together with a few works that can be linked to the development of the still life. It is here that Rembrandt stands far apart from the new Dutch taste. At a time when people buying works of art wanted rich and elaborate compositions, he painted a dramatic picture, such as *The Slaughtered Ox*, a metaphor for death.

■ Rembrandt, *Girl with Dead Peacocks*, c.1639, Rijksmuseum, Amsterdam. Rembrandt uses the dead bird hanging by its legs in a strongly narrative manner, in a picture in which the girl's feelings of curiosity, fear, and compassion prevail.

■ Jan Baptist Weenix, *Dead Partridge*, c.1657, Mauritshuis, the Hague. Dutch still lifes made frequent, skilful use of the *trompe l'oeil* device.

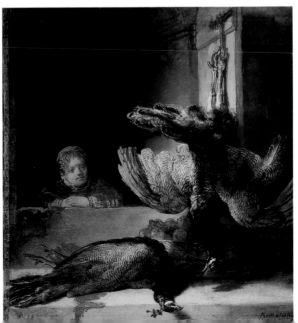

■ Rembrandt, *Landscape with a Stone Bridge*, c.1636, Rijksmuseum, Amsterdam. This is possibly Rembrandt's most famous landscape. Equally important, and often more spontaneous and direct, are his many landscape drawings and engravings.

■ Rembrandt, *Self-portrait with Bittern*, (detail), 1639, Gemäldegalerie, Dresden. The hidden meaning of this highly unusual treatment of the self-portrait has yet to be explained.

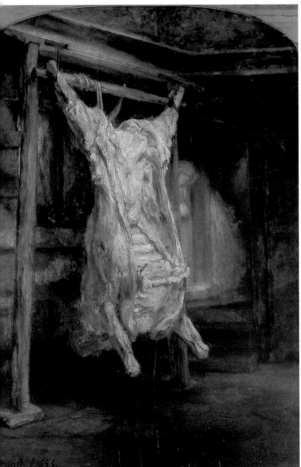

■ Rembrandt, *The Slaughtered Ox*, 1655, Musée du Louvre, Paris. A memorable painting, frequently imitated and reinterpreted (for example, by Picasso and Bacon), this work is based on the direct observation of butchers at work. In between the sketch and the finished painting, the butchers were removed to allow the enormous carcass to take centre stage.

Emerging artists and cities: Vermeer of Delft

■ Jan Vermeer, *Servant Pouring Milk*, 1658–60, Rijksmuseum, Amsterdam. This painting led to the "rediscovery" of Vermeer. Noticed by the English painter Joshua Reynolds at the end of the 18th century, the work had gone from collection to collection. Finally acquired by the Rijksmuseum, the serious, well-built girl is almost a symbol for 17th-century Holland as a whole: flourishing and parsimonious, physically heatlhy, and morally virtuous.

Halfway through the 17th century, a precious, refined painter began his artistic career: Jan Vermeer, whose surname is often qualified by the addition of his native city of Delft to avoid confusion with other artists of the same name. Today, Vermeer is regarded as one of the greatest and most intense European 17th-century painters, but he was not very successful in his day and, after his death, was quickly and almost entirely forgotten. Paintings by his own hand are undoubtedly very few but they are nevertheless sufficient to illustrate the turning point in art that they brought about. Although remaining within the Dutch tradition and taste, Vermeer did not restrict himself to an affectionate description of family and other scenes; instead, he looked for their inner meaning. Cityscapes, domestic interiors, conversations in houses are all pictures drawn from reality, with skilful light effects, but not only visible reality. What Vermeer was really interested in was the soul within his subjects.

■ Jan Vermeer, *The Glass of Wine*, 1655–60, Staatliche Museen, Berlin. Not all Vermeer's paintings exalt chaste femininity. The glass of wine, consumed to the dregs, is a well-known metaphor for sexual availability.

■ Jan Vermeer, *Officer and Laughing Girl*, 1655–60, Frick Collection, New York. The expedient of showing the soldier against the light serves to bring the viewer closer to the girl.

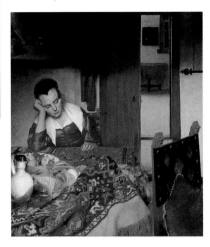

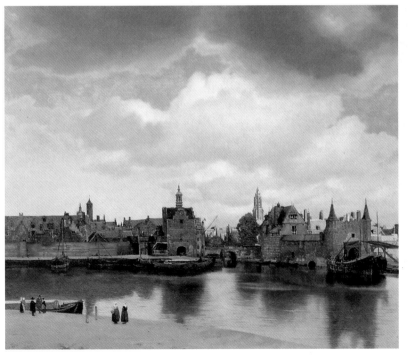

■ Vermeer, *Sleeping Girl*, c.1657, The Metropolitan Museum of Art, New York. Vermeer's best-known paintings are immersed in an atmosphere of silence and intimacy. Here, the viewer almost feels as though he ought to tip-toe out of the room so as not to disturb the girl's slumber.

■ Jan Vermeer, *View of Delft*, 1660–61, Mauritshuis, The Hague. Proust's enthusiasm for this painting, one of the most famous literary celebrations of a painting, emphasizes the success enjoyed by Vermeer in European culture from the end of the 19th century. The Impressionists were also instrumental in contributing to a renewed interest in the Dutch master.

Italian collectors

The considerable difficulties that Rembrandt encountered in the Dutch art market of the 1650s were partly offset by the interest shown in his work by cultured people and collectors throughout Europe. Among these was the Sicilian nobleman Antonio Ruffo, who entered into a long correspondence with the artist. Besides engravings (Ruffo purchased about 200 of these), Rembrandt also sent him some of his paintings: the first and most popular was *Aristotle Contemplating the Bust of Homer*, for which Ruffo paid eight times more than the average sum charged by Italian artists. This was followed by the *Homer* that is now in The Hague, sent unfinished and returned to Rembrandt to be completed, and *Alexander the Great*. A debate arose over this last painting: Ruffo complained that it was made up of four pieces of canvas, roughly stitched together, and Rembrandt offered to take it back and paint a new, but much more expensive version. Two versions of the work exist.

■ Rembrandt, *Homer Dictating to a Scribe*, c.1660, Statens Konstmuseer, Stockholm. This drawing is a variation of the painting in The Hague. The patron, Antonio Ruffo of Messina, wanted to build up a kind of triptych: with Aristotle representing philosophy, Homer poetry, and Alexander the Great active life.

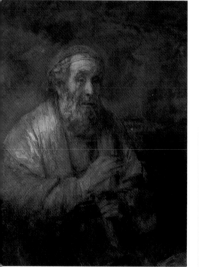

■ Rembrandt, *Homer*, 1663, Mauritshuis, the Hague. A surviving fragment from a larger composition partly destroyed in a fire.

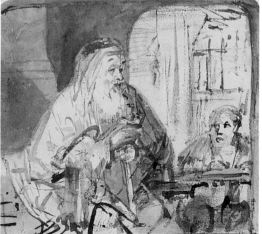

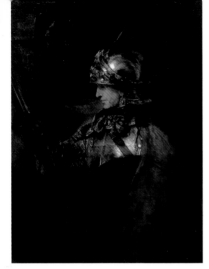

■ Rembrandt, *The Man in Armor*, 1655, City Art Gallery, Glasgow. It is most likely that this, and not the replica housed in the Gulbenkian

Foundation, Lisbon, is the painting Rembrandt sent to Antonio Ruffo.

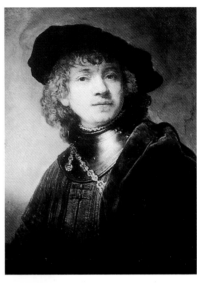

■ Rembrandt, *Self-portrait with Chain and Pendant*, 1668, Uffizi, Florence. This was bought by Cosimo III de' Medici for the self-portrait collection in the Uffizi after meeting the master during a journey to Holland.

■ Rembrandt workshop, *Portrait of Rembrandt with Throat-Piece*, 1634, Uffizi, Florence. The master's signature is not certain. This may be a work produced in the workshop under the direct supervision of Rembrandt.

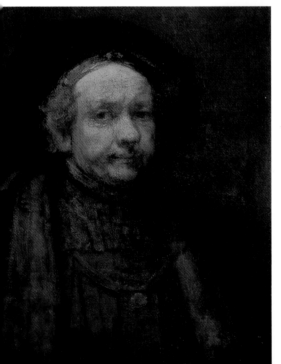

Rembrandt in the Uffizi

Three works bear Rembrandt's name in the Galleria degli Uffizi, Florence, a shrine to Italian Renaissance painting. These are a portrait of an old man in a chair (*Old Rabbi*) of 1661 and the two self-portraits shown here. The interest taken by the Medici in Rembrandt's work is the most significant evidence of the master's fame outside Holland, which had reached as far as the heart of Italy. The purchase made by the future Archduke Cosimo III during a study trip to Amsterdam was followed by Cardinal Leopoldo de'Medici's stormy choice of the youthful self-portrait (even though the attribution was doubtful), which he bought just after Rembrandt's death.

MASTERPIECES

Aristotle Contemplating the Bust of Homer

Now in New York's Metropolitan Museum, this painting dates from 1653. It was painted for the Italian collector Antonio Ruffo, who asked Guercino for a painting that would complement it.

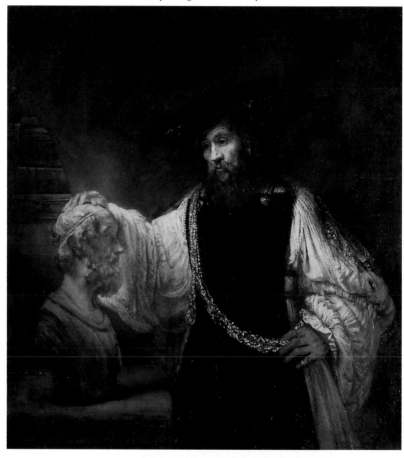

■ Rembrandt, *David Playing the Harp Before Saul*, 1656, Mauritshuis, The Hague. Here, the feeling aroused by the music is comparable to that produced by poetry in *Aristotle Contemplating the Bust of Homer*.

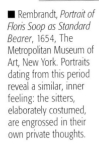

■ Rembrandt, *Portrait of Floris Soop as Standard Bearer*, 1654, The Metropolitan Museum of Art, New York. Portraits dating from this period reveal a similar, inner feeling: the sitters, elaborately costumed, are engrossed in their own private thoughts.

■ Rembrandt, *Moses with the Tables of the Law*, 1659, Staatliche Museen, Berlin. During his years of financial ruin, Rembrandt's solitary heroes grew in dramatic expression.

■ Rembrandt, *Portrait of an Old Man with a Gold Chain*, c.1631, The Art Institute, Chicago. Aristotle's clothes, hat, and chain recall Rembrandt's youthful character studies, such as this, but the manner in which the color is applied is radically different.

Ruin

■ This notice was posted in the streets of Amsterdam to publicize the sale at auction of Rembrandt's possessions in a room of the De Keyserkroon Hotel.

A s a result, among other things, of the recession caused by the war against England, creditors began to put pressure on Rembrandt. The artist had been able to keep them at bay in 1650, thanks to an official valuation of his possessions. Now, however, the situation was grave. In 1653, he asked Jan Six and other friends for help and, putting up his own works as guarantee, he managed to cobble together the money to pay Christoffel Thijssen, the former owner of the house on Sint Anthonisbreestrat, of which Rembrandt had taken possession in 1639 with a down payment of just part of the selling price. With interest added on, he still owed 8,470 guilders. In 1654, Hendrickije gave birth to a girl, for whom Rembrandt once again chose the name Cornelia. He remained in severe financial difficulties, not least because some of his customers were rejecting works they had already bought and demanding a refund. He tried to transfer the ownership of the house to Titus, but the Institute of Orphans opposed the idea. In July 1656, an official inventory of the artist's possessions was drawn up: there were 363 items, including entire collections of drawings, engravings, and paintings by Italian and Flemish masters. Everything was sold in September 1656 for roughly 600 guilders, a derisory sum. In February 1658, the artist's house was sold at auction for 11,2118 guilders. The sale marked the end of a dismal, anguished period.

■ Rembrandt, *Clement de Jonghe*, 1651, etching. Rembrandt hoped to earn more money from the sale of engravings.

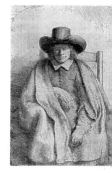

■ This late 17th-century Dutch painting, with its jumble of assorted chattels, gives us an idea of what auctions at this time were like.

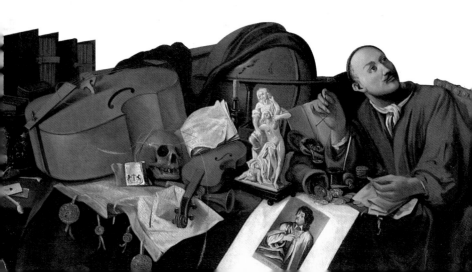

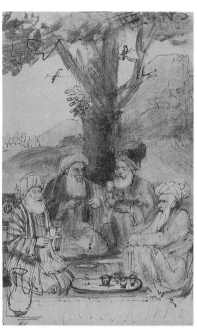

■ Rembrandt, *Four Orientals under a Tree* (copy after an Indian miniature), c.1656, British Museum, London. Among the rare pieces auctioned was a group of Moghul school miniatures, studied and copied by the master.

■ Rembrandt, *Abraham Entertaining the Angels*, 1656, engraving. As this engraving also shows, Rembrandt did not collect exotic works for mere collecting purposes, but also as original sources of inspiration for his work.

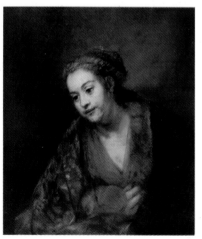

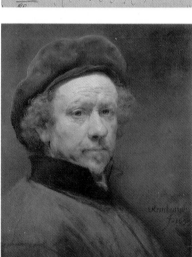

■ Rembrandt, *Self-portrait*, 1657, National Gallery of Scotland, Edinburgh. Despite his economic ruin, Rembrandt's art from this period was indisputably excellent.

■ Rembrandt, *Hendrickije Stoffels*, c.1660, The Metropolitan Museum of Art, New York. Hendrickije displayed an unexpected resilience in adversity.

Jacob Blessing the Sons of Joseph

Now in the Gemäldegalerie, Kassel, this painting dates from 1656. The complex iconography is drawn in a literal manner from a passage in Genesis.

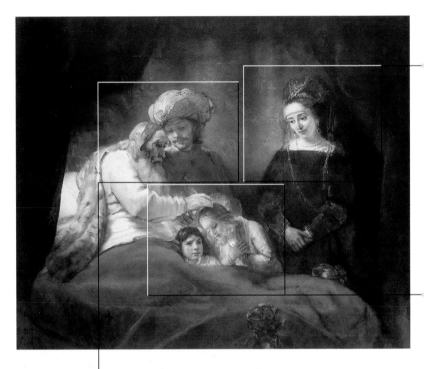

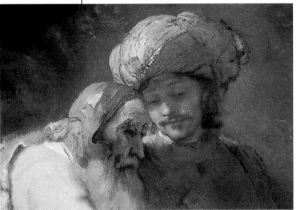

■ The dominant figures in the compositions are the aged Jacob and his son Joseph. The elderly patriarch sits up in bed with some difficulty in order to bless one of his grandsons, effectively entrusting him with the family destiny and the people of Israel. Joseph, however, rebukes his father, who has chosen not the firstborn but his younger brother.

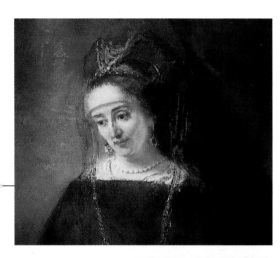

■ Rembrandt's attention and faithfulness to the biblical text has become almost proverbial. Here, however, the artist permits himself a slight departure, inserting a person who does not figure in the text, but who is fundamental for the compositional and psychological balance of the scene: Asenet, Joseph's wife, looks on.

■ Jacob's hand rests on Ephraim's blonde hair. The child bows delicately in a gesture of humility. Next to him is his elder brother Manasse, who is smaller, darker and clearly saddened by his grandfather's incomprehensible favoring of Ephraim.

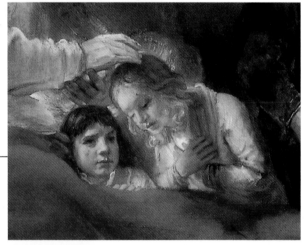

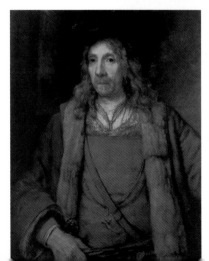

■ Rembrandt, *Portrait of a Man in a Fur Coat*, 1654–56, Museum of Fine Arts, Boston. Dating from the same period as *Jacob*, this work is similar to it in style, with wide, richly colored brushstrokes, undoubtedly inspired by Titian, to whose work Rembrandt's style grew increasingly close.

1658 – 1669

Self-portrait Holding his Palette, Brushes and Mahlstick, c.1665, Kenwood House, London.

Titus, Rembrandt's great hope

Rembrandt adored his son Titus. He was also the father of a daughter, born at the beginning of his relationship with Hendrickije Stoffels, but Titus was a living, bittersweet memory of Saskia, who had died not long after his birth. Rembrandt watched the boy grow up with love and pride. Blonde, refined, and, intelligent, Titus appeared to be delicate, however, and his early death proved dramatically that his health had never been good. The beautiful portraitsof him painted by Rembrandt express a powerful feeling of affection and protectiveness. Titus returned his father's love wholeheartedly: he was a source of comfort to Rembrandt during the dark years of penury and was also of practical help to his father (the artist signed over all his possessions to his son, to escape the claims of his creditors). It was Titus who replaced Saskia as the inspiration for some of Rembrandt's most moving masterpieces.

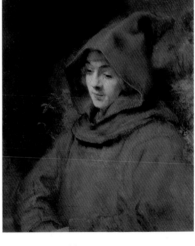

■ Rembrandt, *Portrait of Titus Dressed as a Monk*, c.1660, Rijksmuseum, Amsterdam. Titus harboured no monastic leanings: Rembrandt liked to paint his son dressed up in a variety of unusual costumes.

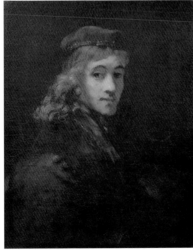

■ Rembrandt (and workshop?), *Portrait of Titus in a Hat*, c.1660, Musée du Louvre, Paris. Like other members of the family (the artist's mother, Saskia, and his sister), Titus was also painted many times by both the master and his pupils. There was such a strong mutual affection between Rembrandt and his family that it is almost inconceivable for Saskia or Titus to have posed for other colleagues. The belief that they may have done has held up the historical and critical analysis into the master's work.

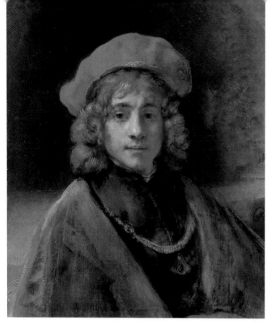

■ Rembrandt, *The Artist's Son Titus*, c.1658, Wallace Collection, London. Here, the figure of Titus seems to be enveloped by his father's concern and care for him.

■ Rembrandt, *Portrait of Titus Reading*, c.1658, Kunsthistorisches Museum, Vienna. In this tender portrait of the young Titus in all his callowness, wonder, and hope, Rembrandt's feelings are clear. The painting becomes an inner diary, an avowal of fatherly affection.

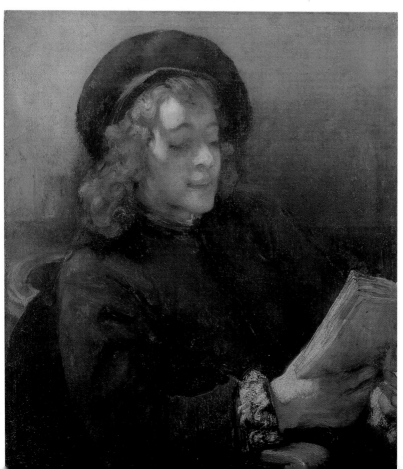

The group portraits of Frans Hals

O ne of the most representative and important Dutch 17th-century painters was actually Belgian: Frans Hals was born in Antwerp shortly after 1580. His Flemish origins may account for the luxuriant exuberance of his work, which can be compared to the paintings of Pieter Paul Rubens. His entire artistic life, however – he began late, after the age of 30 – was spent in the beautiful, wealthy, and commercially lively city of Haarlem, in the agricultural heartland of Holland, among endless fields and canals dotted with windmills. Frans Hals introduced a note of vibrant cheer into this restful but rather dull landscape. His portraits, especially those dating from his early mature phase, display an explosive power, particularly through their obviously quick, color-laden brushstrokes. Almost exclusively a portrait painter, Hals excels in busy group scenes, crowded with figures: solemn banquets, commemorative works, parades of members of the civic guard, hospital governors. His main works are housed in the museum named after him in Haarlem. He died in 1666.

■ Frans Hals, *The Merry Drinker*, c.1635, Rijksmuseum, Amsterdam. This is one of the artist's most famous portraits, full of life and good cheer. The sitter offers us a glass with his left hand, openly inviting us to join him in a toast.

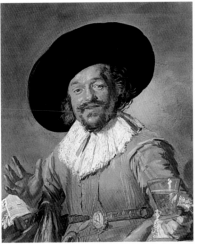

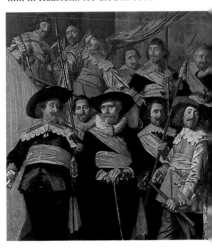

■ Frans Hals, *Officials of the Guard of St George*, 1639, Hals Museum, Haarlem. Frans Hals' group portraits are richly varied. Here, he arranges his sitters according to a complex hierarchy of importance, with the most prominent at the front.

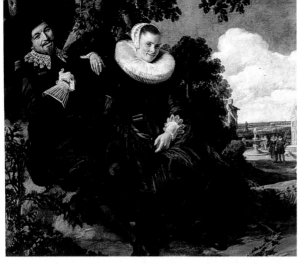

■ Frans Hals, *Isaac Massa and his Wife*, 1622, Rijksmuseum, Amsterdam. The couple's happiness enlivens the whole painting, certainly one of the most cheerful in 17th-century Dutch art. The background recalls Haarlem's late Mannerist painting, but Hals counterbalances this with a new compositional structure that gives the scene a *plein air* effect.

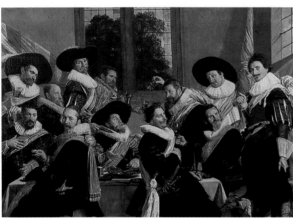

■ Frans Hals, *Officers of the Civic Guard of St Hadrian at Haarlem*, 1627, Frans Hals Museum, Haarlem. The exuberant use of color is one of the characteristic features of Frans Hals' mature style, when he was fully confident in the handling of large groups on canvas.

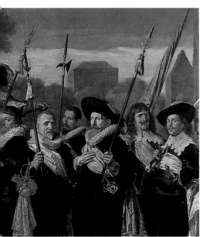

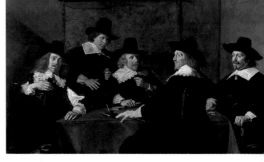

■ Frans Hals, *The Governors of the Hospital of St Elizabeth*, 1641, Frans Hals Museum, Haarlem. In later years, Hals's figures, often in black, became more sober and severe.

113

The Syndics

In 1662, having regained favor with Amsterdam patrons, Rembrandt painted *The Portrait of the Syndics of the Clothmakers' Guild* (sometimes known as *The Syndics*), now housed in the Rijksmuseum, Amsterdam.

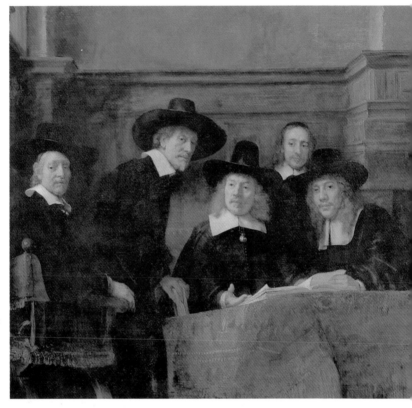

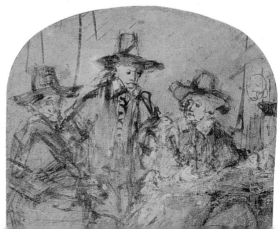

■ Rembrandt, *Three Members of the Clothmakers' Guild*, Kupferstichkabinett, Berlin. From the earliest sketches, at the heart of the composition is the book of cloth samples, which the members of the Clothmakers' Guild (Syndics) are studying.

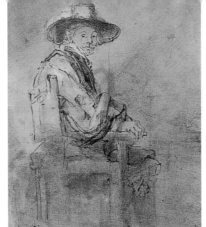

■ Rembrandt, *A Member of the Clothmakers' Guild*, Rijksmuseum, Amsterdam. Rembrandt prepared the painting over a long time, producing several drawings portraying the members both individually and collectively and exploring alternative viewpoints.

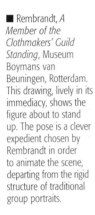

■ Rembrandt, *A Member of the Clothmakers' Guild Standing*, Museum Boymans van Beuningen, Rotterdam. This drawing, lively in its immediacy, shows the figure about to stand up. The pose is a clever expedient chosen by Rembrandt in order to animate the scene, departing from the rigid structure of traditional group portraits.

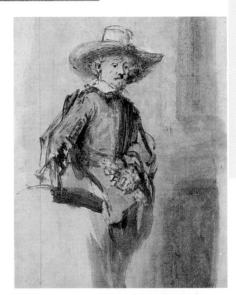

■ Ferdinand Bol, *The Governors of the Amsterdam Leper Hospital*, 1649, Rijksmuseum, Amsterdam. This similar painting by one of Rembrandt's pupils shows an illustrative and narrative precision, in contrast to Rembrandt's overall inventive power.

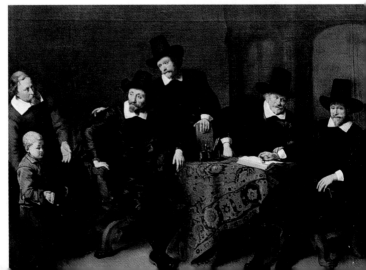

Amsterdam's new town hall

The Dam is the nerve centre of Amsterdam. The square opens out in the dense network of streets and canals in front of one of the most imposing buildings in the city, the royal palace. The name, and its royal connection, however, are historically recent: this great building started out as a town hall. The ornamental bas-reliefs, the large *Maiden of Amsterdam* statue, and the allegory of justice on the façade are testament to this original administrative function. The building is regarded as a supreme masterpiece of Dutch architecture of the mid-17th century and is clearly inspired by stately models from Renaissance classicism. It was built by the gifted architect Jacob van Campen, who completely restored the building after it was damaged by fire in 1652. The decoration of the restored interior naturally represented a most challenging commission for Dutch artists. The style of the building, and the Italianate taste in vogue at the time did not make Rembrandt an obvious choice for involvement: indeed, the most important paintings were commissioned from Govaert Flinck. Within a few years, however, Rembrandt also became involved in the enterprise, through his grandiose painting of the Conspiracy of Julius Civilis, leader of the Batavians, the ancient inhabitants of Holland who rebelled against the Roman invaders.

■ Rembrandt, *The Ruins of the Old Town Hall after the Fire of 7 July 1652*, 1652, Rembrandt's House, Amsterdam. The fate of the old town hall is dramatically depicted.

■ This drawing of Jacob van Campen was taken from a lost painting by Frans Hals.

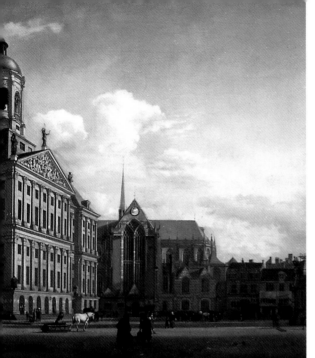

■ Jan van der Heyden, *The Dam at Amsterdam*, Historisch Museum, Amsterdam. The square remains the heart of the city to this day. Behind the façade of the new town hall (now the royal palace) can be seen the apse of the Gothic Nieuwe Kerk, where exhibitions are often held. This splendid painting, which must have been executed with the help of a camera obscura, emphasizes the wide, clear volumes of the town hall. The building is a supreme example of the classical style, inspired in part by works by the 16th-century Andrea Palladio, whose work had been introduced to Dutch culture by van Campen.

■ Below: Pieter Saenredam, *The Old Town Hall, Amsterdam* (detail), 1641–57, Rijksmuseum, Amsterdam. As an inscription explains, this work was first sketched out in 1641, then revised much later in order to record the by-now destroyed building.

■ Right: Jan van der Heyden, *The New Town Hall at Amsterdam*, Musée du Louvre, Paris. The painting has been partly cut on the left and has thus lost its compositional harmony. The viewpoint, different from that in the painting above, here favors the church.

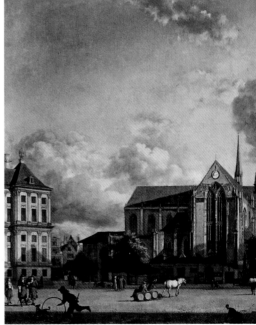

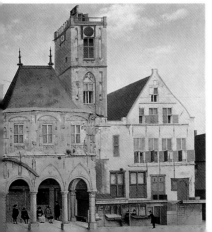

The Conspiracy of Julius Civilis

Executed in 1661 for Amsterdam's new town hall, this painting has had a troubled history. All that survives is the central fragment of the composition, which is badly damaged. It is housed in the Statens Konstmuseer, Stockholm.

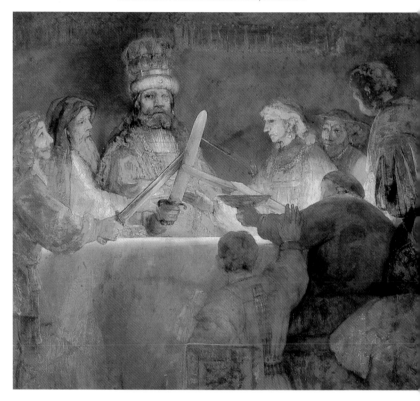

■ Rembrandt, *Ahasuerus and Haman at the Feast of Esther*, 1660, Pushkin Museum, Moscow. Many scenes with figures set around a table recall *The Last Supper* by Leonardo. Rembrandt's expressive and compositional freedom is always balanced and tempered by a careful study of the great Renaissance prototypes.

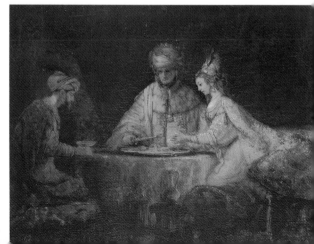

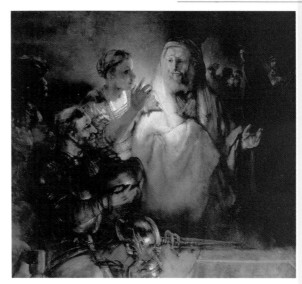

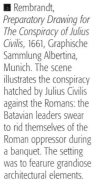 Rembrandt,
Peter's Denial,
c.1660, Rijksmuseum,
Amsterdam. As in *The
Conspiracy of Julius
Civilis*, Rembrandt
exploits the nocturnal
atmosphere to make
the episode more
dramatically charged.

It is interesting to
note in this painting
the clear disproportion
of the figures' unnaturally
large hands, an effect
often employed by
Rembrandt to emphasize
gestural expressions.

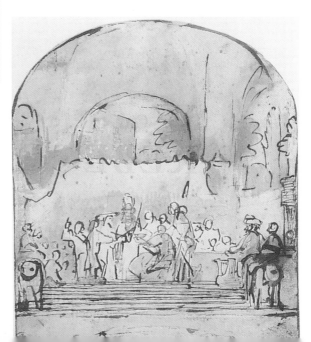 Rembrandt,
*Preparatory Drawing for
The Conspiracy of Julius
Civilis*, 1661, Graphische
Sammlung Albertina,
Munich. The scene
illustrates the conspiracy
hatched by Julius Civilis
against the Romans: the
Batavian leaders swear
to rid themselves of the
Roman oppressor during
a banquet. The setting
was to fearure grandiose
architectural elements.

Rembrandt's old age and the memory of Titian

In 1663, Rembrandt had once again to mourn the loss of a loved one: Hendrickije Stoffels, the final companion of his life, died, styling herself in her will as the artist's "wife". For a few years, Rembrandt had been living in a modest house on the Rosengracht, having surrendered the comforts of the beautiful, large house on the Breestrat. In order to minimize his problems with the public revenue and his creditors, he had worked out a complicated legal strategy: he registered himself as a man of no property, defining himself a dependant of Hendrickije and his son Titus, who gave him board and lodging in exchange for his paintings and engravings, to which the two held the exclusive rights. Prices of his paintings thus started to rise once again, and he was increasingly admired abroad. Public commissions also resumed, but the artist remained destitute and was even forced to sell Saskia's tomb. Meanwhile, his style moved even closer to the memory of Titian.

■ Below: Rembrandt, *Hendrickije as Flora*, 1657, The Metropolitan Museum of Art, New York. Here, the Titianesque model is brought up to date for the artist's new companion.

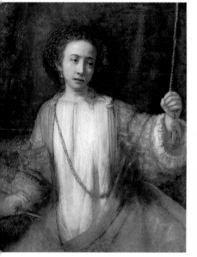

■ Rembrandt, *The Suicide of Lucretia*, 1666, Institute of Arts, Minneapolis. The model for this work was an actress, but this beautiful painting may have evoked the death of Hendrickije.

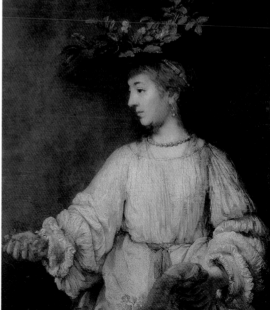

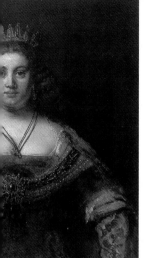

■ Rembrandt, *Juno*, c.1665, Armand Hammer Collection, Los Angeles. This quickly executed painting was produced for the collector Harmen Becker.

■ Rembrandt, *Portrait of Frederick Rihel on Horseback*, 1663, National Gallery, London. The manner of Titian is clear in this unusual commemorative portrait.

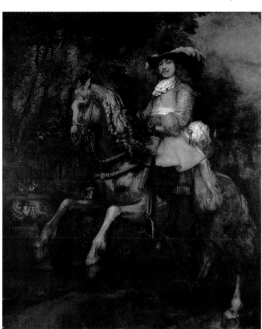

■ Titian, *Flora*, 1516, Galeria degli Uffizi, Florence. The sensual female figure is a constant model in Rembrandt's work. He adopted the spirit and style of Titian several times in his portraits of women.

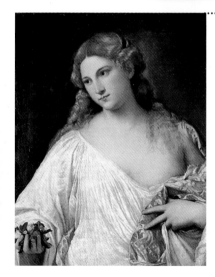

Titian and the "unfinished" style

The stylistic links between Rembrandt and Titian are more obvious in the Dutch master's later work. In particular, Rembrandt systematically adopted a singular, decidedly Titianesque way of applying color: the so-called unfinished style. The late canvases of both artists may appear to be incomplete, almost sketched in. In fact, these are totally finished works, but not revised or touched up, the bare color left clearly in view, with thick, heavy brushstrokes. According to a contemporary, a portrait by Rembrandt was "so thick with color you could lift it up with your nose".

The Jewish Bride

Dating from about 1667, this masterpiece of affection and tenderness is in the Rijksmuseum, Amsterdam. The figures have never been positively identified: the work may celebrate the wedding of a Jewish poet.

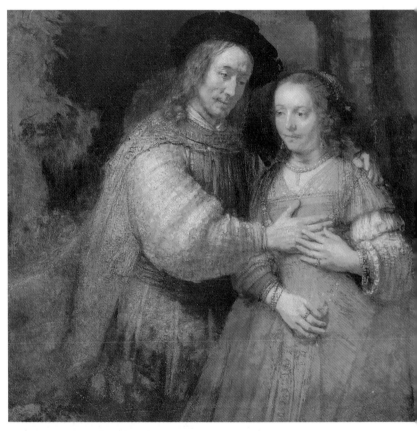

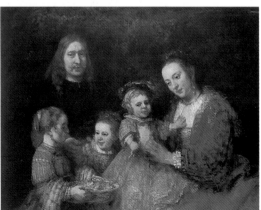

■ The same intense depiction of family loves, expressed incomparably in *The Jewish Bride*, can also be seen in *Family Group* (Herzog Anton Ulrich-Museum, Brunswick), dating from the same period. This work is also similar in its threadlike golden lights on the red fabric.

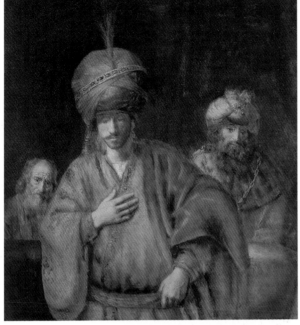

■ Rembrandt, *Haman Sees His Own Death*, c.1665, State Hermitage Museum, St Petersburg. Another painting similar in style to *The Jewish Bride*, this work confirms Rembrandt's direction in his late phase: the wish to express controlled passions and emotions, rather than the explicit feelings he had favored in his youth. Inner meditation now prevails over theatricality.

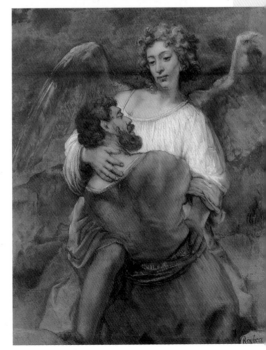

■ Rembrandt, *Jacob Fighting the Angel*, c.1660, Staatliche Museen, Berlin. The embrace depicted in this work, totally different from that in *The Jewish Bride*, stresses Rembrandt's exceptional subtlety of feeling.

The pupils

Pupils, apprentices working to a contract, paying visitors to his studio: Rembrandt was always surrounded by a small retinue of assistants to whom he devoted a great deal of time and attention, more so than most of the other great masters. Even during the darkest years of his economic decline, when he was morally ostracized by the puritan circles of Amsterdam, he was always willing and able to teach the secrets of art to aspiring colleagues. His teaching success, however, poses something of a problem in retrospect. Many of his pupils imitated the master's style, to the extent of creating serious difficulties in the precise attribution of his works. Only a handful of his pupils achieved autonomous artistic fame, with a clearly recognizable, independent style. Centuries of dealing have contributed further to these problems, with forged signatures on paintings, copies, replicas, and works by other artists. The Rembrandt Research Project, formed through the initiative of some of the world's major museums, is in charge of the study and correct attribution of the artist's works, with the help of an international team of art specialists and restorers.

■ Rembrandt's circle, *Man with a Golden Helmet*, Staatliche Museen, Berlin. One of the Rembrandt Research Project's most controversial finds was the "demoting" of this painting's attribution; for a long time held to be by Rembrandt, it is now known to be the work of an unidentified pupil.

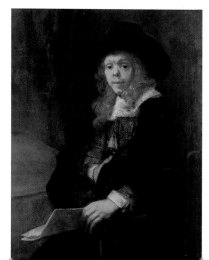

■ Rembrandt, *Gérard de Lairesse*, 1655, The Metropolitan Museum of Art, New York. Facially deformed, treatise-author De Lairesse was one of the major Dutch writers on art. A supporter of Rembrandt, he differed from the master in suggesting Dutch painting turn towards classicism.

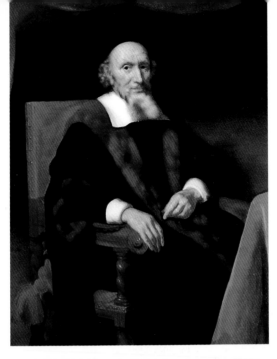

■ Left: Nicolaes Maes, *Jacob Trip*, 1659–60, Mauritshuis, The Hague; below left: Rembrandt, *Portrait of Jacob Trip*, 1661, National Gallery, London. A comparison between these two works, which portray the same person, speaks for itself. The pupil is precise, analytical, and describes the facial features and social standing of the subject, whereas Rembrandt concentrates more on the likeness and recognizability of the sitter. He gives Jacob Trip an aura of high moral dignity, almost as if he were a biblical figure.

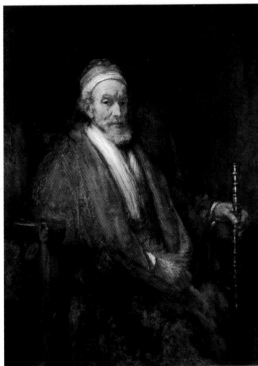

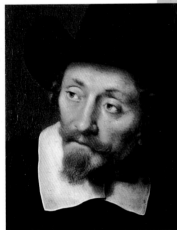

■ Ferdinand Bol, *The Governors of the Amsterdam Leper Hospital*, 1649, Rijksmuseum, Amsterdam. The works of Bol, one of Rembrandt's best pupils, have often been mistaken for the master's own.

A shattered family

Titus celebrated many important events in his young life. When he attained his majority, he was finally able to inherit his share of his mother's money. On February 10, 1668, he married Magdalena van Loo, the niece of Saskia's sister, and soon after the wedding, to the delight of the ageing Rembrandt, the couple announced that they were expecting a child. The last months of 1668 were a whirlwind of emotions for the artist. Titus's marriage to his second cousin brought back memories of the past, of the years he spent with Saskia, of the happiest time of his life. In September, however, tragedy struck once again: Titus died, and Rembrandt sank into the depths of solitude.

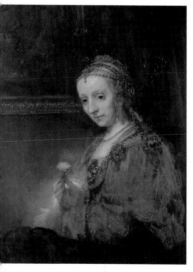

He remained alone in the sparsely decorated house on the Rosengracht with Cornelia, the daughter Hendrickije had borne him 15 years earlier. He was tired, desultorily living off bread and cheese. On March 22, in tears, he attended the baptism of his granddaughter, who was named Titia. The unfortunate child would soon lose her mother, as well. Meanwhile, her grandfather tried to keep his grief at bay by clinging to his painting.

■ Rembrandt, *Portrait of a Woman Holding a Carnation*, c.1665, Metropolitan Museum of Art, New York. Saskia's touching pose of many years before is repeated in this painting.

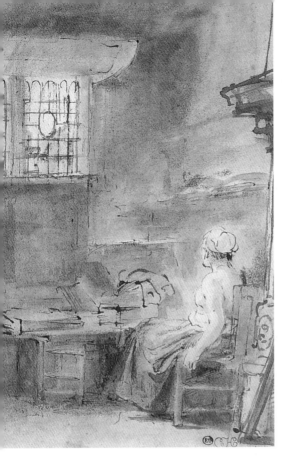

■ Rembrandt, *A Model in the Artist's Studio*, c.1665, Ashmolean Museum, Oxford. This drawing, executed at the time of his financial embarrassment, shows Rembrandt's studio, once full of pupils and all manner of precious objects, but now empty.

■ Rembrandt and follower, *Simeon with the Christ Child in the Temple*, 1669, Statens Konstmuseer, Stockholm. "Lord, now lettest thou thy servant depart in peace". These words are spoken by the aged preacher in one of the most poetic verses of the Bible. This was Rembrandt's last painting, in which he bared his soul yet again. Like the old man in the picture, Rembrandt was left holding an infant – his granddaughter, Titus' daughter.

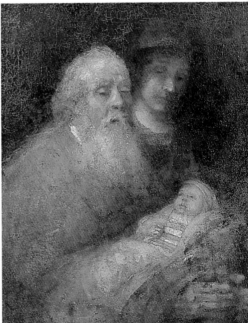

■ Rembrandt, *View of the River Y from the Diemerdyke*, Devonshire Collections, Chatsworth. Rembrandt's last landscape drawings echo the way in which he reviewed his whole life, looking at it from a distant, almost secret viewpoint, no longer part of the scene but as a faraway observer.

MASTERPIECES

The Return of the Prodigal Son

A late masterpiece, dating from 1668, this painting is now in the State Hermitage Museum, St Petersburg. It is likely that the emotional meaning behind this large canvas (the figures are life-sized) is connected with Titus' death.

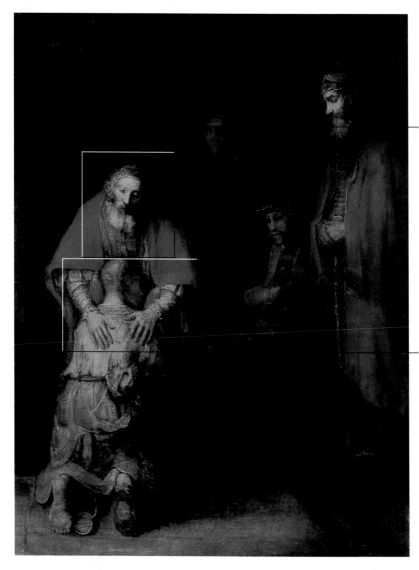

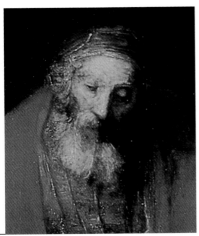

■ Rembrandt had already drawn on this theme in an engraving, *The Prodigal Son,* executed 30 years before. The composition differs from that in the painting in that it is less emotional. A comparison between the two works underlines the exceptionally powerful and personal message of the painting.

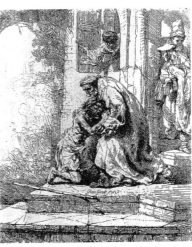

■ The father is not Rembrandt himself, but rather a kind of archetypal paternal figure, who would never forsake his son. The father's pose is deeply felt: he appears to enfold his repentant son in a physical and moral embrace, isolating him from an outside world that is incapable of understanding total and unreserved love.

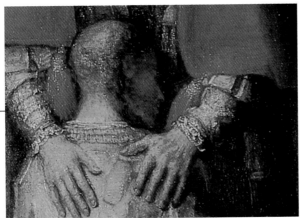

■ The embrace has an important precedent in Rembrandt's work. It appears in the dramatic *Farewell of David and Jonathan*, painted in 1642 on the occasion of Saskia's death. This painting is also housed in the Hermitage.

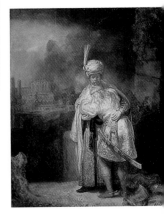

■ The father's large hands rest on the shoulders of his kneeling son. They feel the young man's weakened body through the coarse fabric of his ragged clothes. The roles are reversed: it is the frail old man who protects the young man, holding him close in a protective embrace. Rembrandt, however, can do nothing for Titus: his son can never return.

The last self-portraits

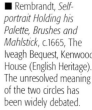

And so Rembrandt's life ended, colored by the bitterness of loss. He devoted his final paintings, the last pages in a lifetime's diary, to his own image in self-portraits in which the quality of his achievement is undiminished. Few artists can be compared with Rembrandt in the history of art; perhaps the only possible parallel can be found in Titian, who, shortly before his death, had also seen his favorite son fall victim to a fatal illness. For Titian, as for Rembrandt, death was the end of a final journey through an arid, loveless desert made bearable only by work. In the self-portrait in Kenwood House, palette and brushes form a single entity with the hand, almost becoming an extension of it. Rembrandt's death, in 1669, marked the end of an era and of the rarefied world that was Holland during the so-called Golden Age. Dutch painting and lifestyle underwent a change, moving towards an anonymous, Frenchified conformity. The artist's death went virtually unnoticed, but it was not long before his fame spread across the world.

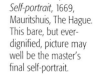

■ Rembrandt, *Self-portrait*, 1669, Mauritshuis, The Hague. This bare, but ever-dignified, picture may well be the master's final self-portrait.

■ Rembrandt, *Self-portrait Holding his Palette, Brushes and Mahlstick*, c.1665, The Iveagh Bequest, Kenwood House (English Heritage). The unresolved meaning of the two circles has been widely debated.

■ Rembrandt, *Self-portrait*, 1669, National Gallery, London. The artist's proud demeanor shines through, even in the years of his physical decline.

■ Jan van der Heyden, *View of the Westerkerk, Amsterdam*, c.1660, National Gallery, London. Rembrandt was buried here on October 8, 1669.

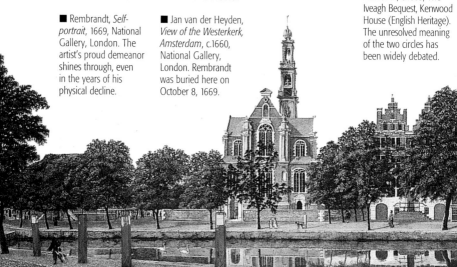

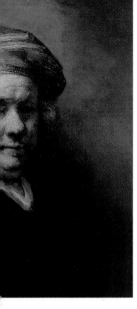

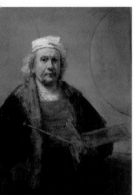

■ Rembrandt, *Self-portrait*, 1629, Alte Pinakothek, Munich. By the time of the artist's death, forty long years of vicissitudes had passed since this curious, eager young man faced the world. His expression of surprise and vitality became the look of resignation of a disenchanted old man.

■ Rembrandt, *Self-portrait Laughing*, 1669, Wallraf Richartz Museum, Cologne. This painting is the artist's final joke, taking his leave of us in the guise, possibly, of the Greek painter Zeuxis, who died laughing excessively at his own painting of a wizened old woman.

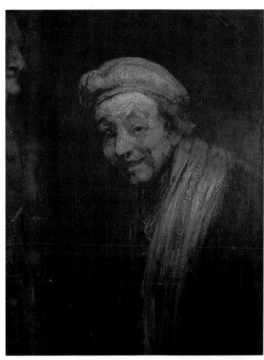

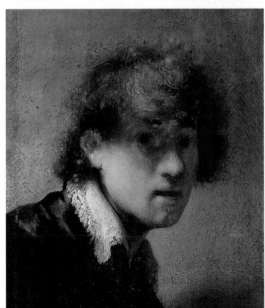

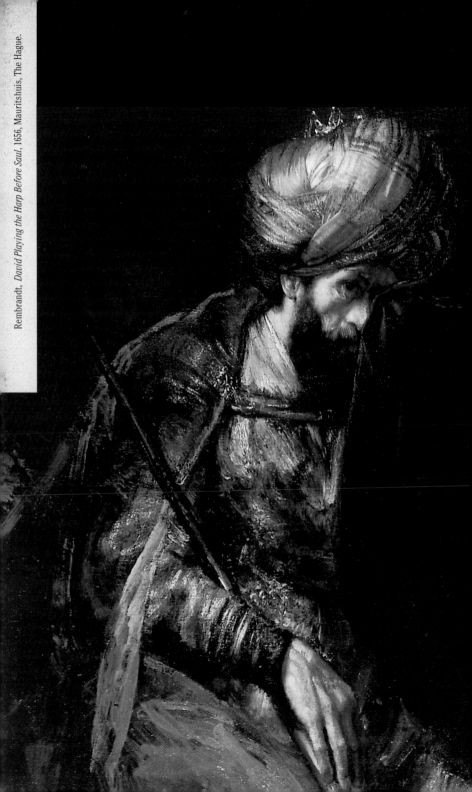

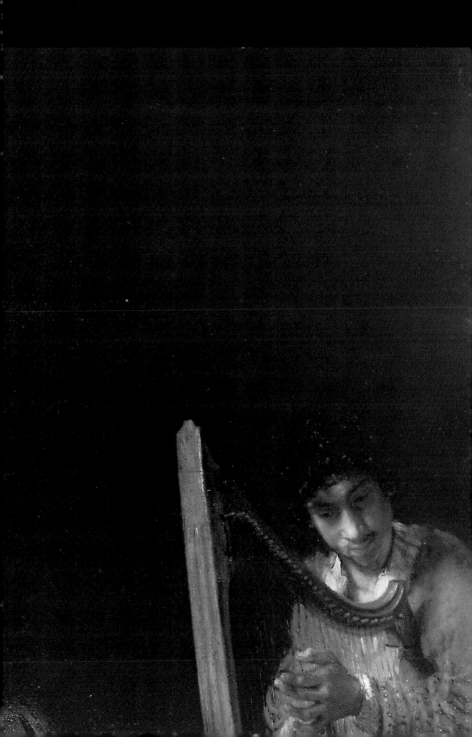

Index

■ The Mauritshuis, The Hague.

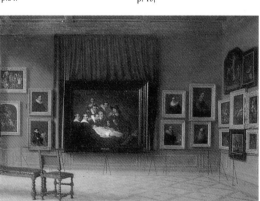

■ Antoon François Heijligers, *Interior of the Rembrandt Room in the Mauritshuis*, 1884, Mauritshuis, The Hague.

■ Rembrandt, *Bust of a Man in Oriental Costume*, 1633, Alte Pinakothek, Munich.

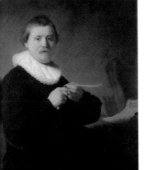

■ Rembrandt, *Portrait of a Man Sharpening a Quill Pen*, 1632, Staatliche Museen, Gamäldegalerie, Kassel.

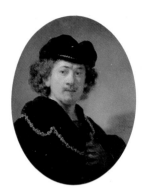
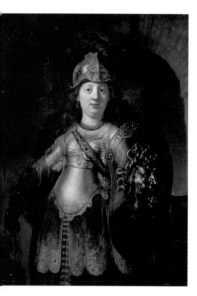

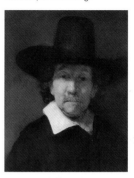

■ Rembrandt, *Portrait of Jeremias de Decler*, 1666, State Hermitage Museum, St Petersburg.

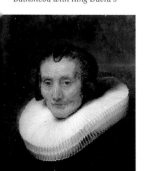

■ Rembrandt, *Portrait of Aletta Adriaensdr.*, 1639, Museum Boymans van Beuningen, Rotterdam.

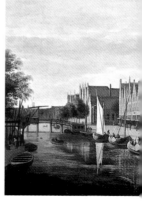

■ Gerrit Berckheyde, *The Spaarne at Haarlem*, c.1670, Rijksmuseum, Amsterdam.

Note

All the names mentioned here are artists, intellectuals, politicians, and businessmen who had some connection with Rembrandt, as well as painters, sculptors, and architects who were contemporaries or active in the same places as Rembrandt.

Anslo, Cornelis Claeszoon, one of Holland's best-known preachers. He was portrayed by Rembrandt together with his wife in a painting dating from 1641, now in Berlin, pp. 66–67.

Backer, Jakob Adriaenszoon (Harlingen 1608 – Amsterdam 1651), Dutch painter. A pupil and colleague of Rembrandt's, painter of historical subjects and hunting scenes, Backer is known most of all for his activity as a portrait painter, p. 71.

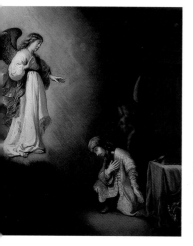

■ Jakob Backer, *The Angel Appearing to Cornelius, Centurion in Galilee, during Prayers and Fasting*, Bader Collection, Milwaukee.

Banning Cocq, Frans, captain of the Amsterdam civic guard portrayed in *The Night Watch*, the famous painting by Rembrandt dating from 1642, pp. 70, 72–73.

Belten, Pieter, owner, together with Christoffel Thijssens, of the house on Sint Anthonisbreestraat in Amsterdam, which Rembrandt bought in 1639 for 13,000 guilders, p. 64.

Berckheyde, Gerrit (Haarlem 1638 – 1698), Dutch painter. A pupil of Frans Hals and his brother Job, he painted mainly urban views of Amsterdam, Haarlem, and The Hague, p. 87.

Beyeren, Abraham Kendrickszoon van (The Hague c.1620 – Overschie 1690), Dutch painter of marine scenes and still lifes, van Beyeren also painted many famous meal scenes. His work is celebrated for its wide variety of subject-matter, p. 95.

Bol, Ferdinand (Dordrecht 1616 – Amsterdam 1680), Dutch painter and engraver. A pupil of Rembrandt, he enjoyed considerable success among the Amsterdam gentry through his portraits, pp. 115, 125.

Bosschaert, Ambrosius (Antwerp 1573 – Middelburg 1621), Dutch painter. He specialized in the still life genre, favoring in particular elaborate and colorful floral arrangements, p. 9.

Campen, Jacob van (Haarlem 1595 – Amersfoort 1657), Dutch architect. He was one of the main exponents of Dutch classicism inspired by the architectural works of Andrea Palladio. He rebuilt the Amsterdam Town Hall after it was destroyed by fire in 1652, pp. 116–17.

Caravaggio (Michelangelo Merisi, Milan 1571 – Porto Ercole 1610), Italian painter. His work is characterized by strong contrasts between light and shade that are able to evoke atmosphere and mould the figures by stressing their inner drama and the religious meaning of the scenes represented, pp. 14–17.

Codde, Pieter Jacobszoon (Amsterdam c.1599 – 1678), Dutch painter. He may have been

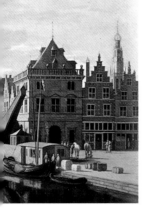

a pupil of Frans Hals and painted interiors, portraits, and social gatherings, p. 69.

Dircx, Geertje, farmer's widow from Zeeland. She became Rembrandt's mistress after the death of the artist's wife in 1642, pp. 82–83, 88.

Dou, Gerrit (Leiden 1613 – 1675), Dutch painter. He worked in Rembrandt's workshop from 1628 to 1630. His elegant paintings, of diminutive proportions, are characterized by their extremely precise and detailed execution, pp. 26–27.

Dürer, Albrecht (Nuremberg 1471 – 1528), German painter, engraver, and theorist. A singularly gifted artist, he was the true protagonist of central European Renaissance art. In his work, northern elements such as gravity and meticulousness blend with the monumentality and

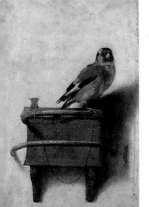

■ Govaert Flinck, *Margaretha Tulp*, 1655, Staatliche Museen, Gemäldegalerie, Kassel.

sense of color drawn from Italian Renaissance models, pp. 12–13, 53.

Fabritius, Barendt (Middenbeemster 1624 – Amsterdam 1673), Dutch painter. A pupil of Rembrandt and brother of Carel, he painted costume scenes, portraits, mythological and biblical paintings, p. 63.

Fabritius, Carel (Middenbeemster 1622 – Delft 1654), Dutch painter. One of Rembrandt's most gifted pupils, he was in the master's workshop from 1641 to 1643. His paintings, softer and more luminous than Rembrandt's, anticipate the work of Jan Vermeer, pp. 50, 63.

Flinck, Govaert (Cleves 1615 – Amsterdam 1660), Dutch painter. He was apprenticed in Rembrandt's workshop from 1632 to 1636, painting mainly portraits and religious scenes. He became famous as a painter of historical scenes through his large baroque allegorical canvases, pp. 61–62, 87, 116.

Francken, Frans II (Antwerp 1581 – 1642), Flemish painter. A prominent exponent of the famous family of Flemish painters active between the 16th and the

■ Carel Fabritius, *The Goldfinch*, 1654, Mauritshuis, The Hague.

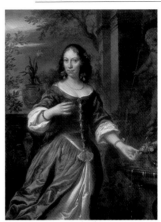

■ Govaert Flinck, *Margaretha Tulp*, 1655, Staatliche Museen, Gemäldegalerie, Kassel.

17th century, he was influenced by the painterly style of Rubens. He spent some time in Rome, where he enjoyed considerable success with his detailed genre and mythological paintings, p. 56.

Gheyn, Jacob III de (Haarlem c.1596 – The Hague? 1644), Dutch engraver. He favored works of a mythological nature, p. 29.

Haarlem, Cornelis van (1562 – 1638), Dutch painter. A refined artist and a key figure in Dutch late Mannerism, Cornelis van Haarlem is regarded as the founder of the baroque current in Haarlem's classicism, p. 93.

Hals, Frans (Antwerp, c.1580 – Haarlem 1666), Dutch painter. A consummate portraitist, he went beyond the Mannerist conventions, restoring truth and a spontaneity of pose and expression to his models, thanks to his choice of subject (women, boys, drinkers, old men) and to

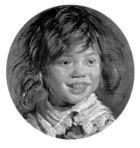

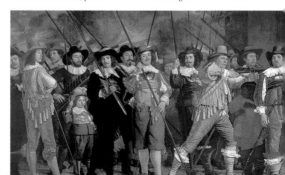

■ Bartholomeus van der Helst, *The Company of Captain Roelof Bicker and Lieutenant Michielsz. Blaeuw.*, 1639, Rijksmuseum, Amsterdam.

■ Pieter lastman,
The Rejection of Hagar and Ishmael, 1612,
Kunsthalle, Hamburg.

lifes featuring musical instruments, p. 79.

Lievens, Jan (Leiden 1607 – Amsterdam 1674), Dutch painter. His youthful works were heavily influenced by Rembrandt, whose studio in Leiden he shared between 1624 and 1631. He later drew inspiration from Van Dyck's courtly paintings, specializing in society portraits, pp. 14, 22–23, 25, 28, 59, 60.

Loo, Magdalena van, wife of Rembrandt's son Titus, p. 126.

Lucas van Leyden (Leiden c.1490 – 1533), Dutch painter and engraver. Known especially for the quality of his draughtsmanship, his works clearly show the inspiration of the Flemish masters and the example of Albrecht Dürer, pp. 12–13.

Maes, Nicolaes (Dordrecht 1634 – Amsterdam 1693), Dutch painter and pupil of Rembrandt, he painted interiors with female figures, pp. 81, 125.

Man, Cornelis de (Delft 1621 – 1706), Dutch painter. His work, stylistically very similar to that of Pieter de Hooch and Jan Vermeer, includes portraits, views of churches, and interiors, p. 38.

Mantegna, Andrea (Isola di Carturo, Padua 1431 – Mantua 1506), Italian painter and engraver and one of the key figures in the Italian Renaissance. His works, characterized by exaggerated plastic and chromatic effects, as well as particular care in the modelling of figures, had a far-reaching influence on his contemporaries and the following generations, p. 53.

Medici, Cosimo III de', Grand Duke of Tuscany from 1670 to 1723. He purchased Rembrandt's *Self-portrait with Chain and Pendant*, p. 101.

Medici, Leopoldo de' (Florence 1617 – 1675), cardinal. A keen art connoisseur, he began the collection of artist's self-portraits in the Uffizi, including also a self-portrait by Rembrandt in it, p. 101.

Metsu, Gabriel (Leiden 1629 – Amsterdam 1667), Dutch painter, possibly a pupil of Gerard Dou. Metsu painted genre scenes as well as allegorical and religious

paintings, all characterized by a detailed execution and elegant light effects, p. 79.

Molenaer, Jan Miense (Haarlem c.1610 – 1668), Dutch painter. His small paintings, which are strongly influenced by the works of Frans Hals and Rembrandt, include interiors, genre scenes, and family group portraits, p. 79.

Orange, Frederick Henry, Prince of, prince of the kingdom of the Low Countries. He was one of Rembrandt's most prestigious clients, pp. 28, 55.

Orange, William of, known as the Silent, prince of the kingdom of the Low Countries. Under his leadership, the Protestant provinces of the Low Countries were able to win their

■ Pieter de Hooch,
Country House, c.1665,
Rijksmuseum,
Amsterdam.

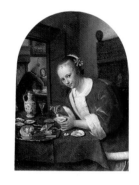

■ Jan Steen, *Girl with Oysters*, c.1660, Mauritshuis, The Hague.

independence from the southern regions, pp. 8–9.

Pickenoy, Nicolaes (Amsterdam c.1590 – c.1655), Dutch painter. A popular portrait artist in Amsterdam, his works are faithful likenesses of their sitters and are characterized by a strong luministic sensibility, p. 68.

Remigia, Rembrandt's maternal grandmother, p. 10.

Renesse, Constantijn van (Maarsen 1626 – Eindhoven 1680), Dutch painter and engraver. A pupil of Rembrandt's, he gave up his career as an artist when he was elected secretary to the city of Eindhoven, p. 61.

Rijn, Cornelia van, Rembrandt's daughter by Hendrickije Stoffels, pp. 104, 126.

Rijn, Cornelia van, Rembrandt's mother, p. 10.

Rijn, Harmen van, miller, Rembrandt's father, pp. 10, 25, 31.

Rijn, Lijsbeth van, Rembrandt's sister, pp. 30, 110.

Rijn, Rombertus van, Rembrandt's son by his wife Saskia, born in 1635. The child lived just two months, p. 43.

Rijn, Titia van, Rembrandt's granddaughter, p. 126.

Rijn, Titus van, Rembrandt's son by his wife Saskia, born in 1641, pp. 30, 76–77, 82–83, 84, 88, 104, 110–11, 120, 126–27.

Rubens, Pieter Paul (Siegen 1577 – Antwerp 1640), Flemish painter. His paintings anticipate the baroque style with their vision of a continuous and illusory space, animated by light effects that are capable of arousing intense emotion in the viewer, pp. 14, 52, 112.

Ruffo, Antonio, Sicilian nobleman. A collector of Rembrandt's works, he corresponded with the artist for some years, pp. 100, 101, 102.

Saenredam, Pieter (Assendelft 1597 – Haarlem 1665), Dutch painter. Saenredam favored landscape painting, specializing in the genre, and may have been influenced by the architectural representations of Jacob van Campen, p. 117.

Six, Jan, friend of Rembrandt, pp. 57, 62, 88–89, 98, 104.

Steen, Jan (Leiden 1626 – 1679), Dutch painter. His oeuvre takes in portraits and genre scenes, as well as religious, mythological, and allegorical subjects. His paintings are characterized by his sharp observation of everyday life in Holland, pp. 8, 95.

Stoffels, Hendrickije, Rembrandt's mistress, pp. 82, 88, 92–93, 104, 105, 110, 120, 126.

Swanenburgh, Isaac van (Leiden c.1538 – 1614), Dutch painter. Linked to the tradition of Bosch, he was Rembrandt's first teacher, p. 13.

Sweerts Michiel (Brussels 1624 – Goa 1664), Flemish painter. His work balances the realism of genre paintings derived from Caravaggio with a classical concept of composition, p. 65.

■ Judith Leyster, *Serenade*, 1629, Rijksmuseum, Amsterdam.

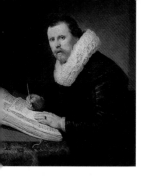

■ Rembrandt, *Portrait of a Man at his Desk*, 1631, The State Hermitage Museum, St Petersburg.

■ Anthony Van Dyck, *Portrait of Marcello Durazzo*, 1621, Galleria Franchetti alla Ca'd'Oro, Venice.

A DK PUBLISHING BOOK
Visit us on the World Wide Web at http://www.dk.com

TRANSLATOR
Anna Bennett

DESIGN ASSISTANCE
Joanne Mitchell

EDITOR
Louise Candlish

MANAGING EDITOR
Anna Kruger

Series of monographs
edited by Stefano Peccatori and Stefano Zuffi

Text by Stefano Zuffi

PICTURE SOURCES
Archivio Electa, Milan; Alinari, Florence
Elemond Editori Associati wishes to thank all those museums and
photographic libraries who have kindly supplied pictures, and would be pleased
to hear from copyright holders in the event of uncredited picture sources.

Project created in conjunction with
La Biblioteca editrice s.r.l., Milan

First published in the United States in 1999 by DK Publishing Inc.
95 Madison Avenue, New York, New York 10016

ISBN 0-7894-4146-2

Library of Congress Catalog Card Number: 98-86757

First published in Great Britain in 1999
by Dorling Kindersley Limited,
9 Henrietta Street, London WC2E 8PS

A CIP catalogue record of this book is available from the British Library.

ISBN 0751307300

2 4 6 8 10 9 7 5 3 1